IMAGES
of America

DENVER'S EARLY ARCHITECTURE

IMAGES
of America

DENVER'S EARLY ARCHITECTURE

James Bretz

ARCADIA
PUBLISHING

Published by Arcadia Publishing
Charleston SC, Chicago IL, Portsmouth NH, San Francisco CA

Printed in the United States of America

Library of Congress Control Number: 2009938069

For all general information contact Arcadia Publishing at:
Telephone 843-853-2070
Fax 843-853-0044
E-mail sales@arcadiapublishing.com
For customer service and orders:
Toll-Free 1-888-313-2665

Visit us on the Internet at www.arcadiapublishing.com

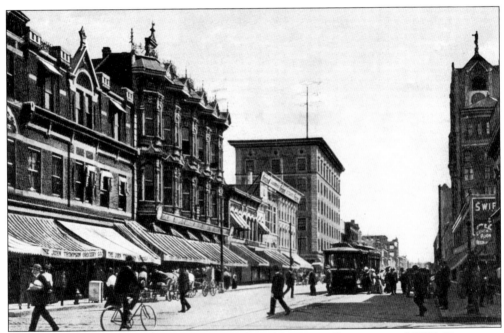

This photograph is looking east from Fifteenth and Lawrence Streets around 1915. Downtown Denver, with its trolley system, horses and carts, bicycles, and sputtering automobiles, was the city's major hub for shopping, business, and entertainment in the days preceding shopping malls and multiplex theaters. The Mining Exchange Building is on the right. Brooks Towers, a residential and retail complex, later replaced it. All the buildings in this photograph are now gone. (Author's collection.)

CONTENTS

Acknowledgments

The author wishes to thank the staff of the Stephen Hart Library of the Colorado Historical Society and the staff of the Denver Public Library Western History Department for their help in the researching of this material, as well as Dodge Meadows of the Grant Street Mansion; Michael's of Denver Catering; Rick Bass; Mark Terrel of the Perrenoud; Pete Jordan and Deborah Ellis of the First Church of Christ, Scientist; Sharon McIntyre; Dorothy Bowie; Ken Larsen; and Martin J. Wohlnich.

Thanks, also, to Mary Ann Davis of the Colorado Trust, Carla Pradia of the Barth Hotel, Rev. Mike Morran of First Unitarian Church, Glenn Barrows of the First Unitarian Society of Denver, and Rozolen Stanford of the Central Presbyterian Church.

Special thanks go to William Gard Meredith and David G. Ricciardi for their unwavering support.

Unless otherwise noted, all images are from the author's collection.

"DPL" denotes the Denver Public Library Western History Department photograph collection.

INTRODUCTION

One cannot and must not try to erase the past merely because it does not fit the present.

—Golda Meir

Denver, Colorado, is a relatively young city compared with those throughout New England, the eastern seaboard, the port cities of the South, and the mission towns of California. Before it was established as a settlement, what was to become the City of Denver was a dusty, barren range set against the foothills of the Rocky Mountains. The Pike's Peak gold rush of the late 1850s brought miners and prospectors to the region, and they eventually established a camp at the confluence of what is now the Platte River and Cherry Creek, an area that was, at that time, part of the Kansas Territory. The Colorado Territory was established in 1861, and Denver became its capital when the Colorado Territory was admitted to the Union in 1876. It was from this point that the City of Denver grew outward in all directions, slowly but persistently, to its present form.

The city's first buildings of the 1850s and early 1860s were rudimentary structures of canvas, logs, and mud, or simple wooden shacks. Flooding was common along the riverbanks. Many of these structures were destroyed by fire. As they were rebuilt, brick was more commonly used as the material of choice, and through the following two decades, many of the earliest, permanent buildings were going up all over the lower downtown Denver area. Simple houses were replaced with more ambitious designs of gingerbread trim, iron railings, widow's walks, and arched windows. Commercial buildings went from one story to two and three.

New construction escalated in the 1880s and 1890s, giving Denver some of its best-known and most architecturally interesting buildings, such as the Masonic and Kittredge Buildings, still standing proudly along Sixteenth Street downtown; the Cheesman and McPhee Buildings; the Metropolitan and Cooper Buildings; the Boston Building, extant amidst the Seventeenth Street financial district, and those that housed the Golden Eagle, Joslin's, the May Company, and the Denver Dry Goods department stores. Interspersed among Denver's early edifices downtown were many smaller buildings where one could find teas and spices, fruits and vegetables, feed and grain, and the occasional general store that sold everything from dill pickles to leather goods and imported lace.

In its early days, downtown Denver was a fairly even mix of commercial and residential properties. Alongside the solidly constructed business offices were many hotels, houses, and apartment buildings. Merchants depended on the carriage trade, and Denver's earliest suburbs stretched no farther than a mile or two from the center of town. Many of the city's residents found their jobs, entertainment, and shopping downtown. Among those who plied their trade were grocers, druggists, doctors, dentists, jewelers, watchmakers, attorneys, and architects, along with now-archaic professions such as wagon makers, milliners, bootblacks, saloon keepers, cobblers, blacksmiths, and brush and broom makers.

Construction in the downtown area came to a virtual standstill during the Great Depression and remained stagnant until the end of World War II, when many of the servicemen who had been stationed at Lowry Air Force Base and Fitzsimons Army Base returned to Denver to live and raise their families.

During the 1950s and 1960s, masses of people took flight to the new suburbs, and downtown began to lose its luster as a shopping and business hub. New housing, shopping malls, and new office parks took the focus away from central Denver. As downtown lost its businesses and shoppers to the suburbs, urban decay set in. Cheap rooms were let in once-elegant hotels, office suites became vacant, and shops closed down. Property values plummeted. Maintenance was deferred, and buildings were neglected. Denver experienced, for the first time in its history, inner-city blight. Downtown residents were now mainly the elderly, the poor, and the disabled. There came a point when the situation could no longer be ignored. Downtown was in limbo, and the city was growing up around it. During the same period, the same thing was happening in Capitol Hill to the east, only to a slightly lesser degree.

The Denver Urban Renewal Authority (DURA) was formed in 1958 as an answer to this predicament. At the onset, its primary purpose was to help give direction to the revitalization of downtown Denver and, to some extent, the surrounding areas. The following year, the Denver City Council gave approval for one of the city's first urban renewal projects—the clearance of slums along Blake Street in lower downtown. A nine-block area was to be partially leveled, with the remaining buildings to be rehabilitated.

In the 1960s, work commenced on destruction of several of the oldest structures in lower downtown. A full block, bounded by Sixteenth, Seventeenth, Curtis, and Arapahoe Streets, was targeted. The Gordon, York, and Whitney Buildings were razed, along with the Londoner Building, named for Wolfe Londoner, one of Denver's early mayors. When the land was leveled it was sold for redevelopment.

In 1966, DURA approved the Skyline Project, a 36-block area bounded by Speer Boulevard, and Curtis, Larimer, and Twentieth Streets. The project was later trimmed to 26 blocks. The severity of the blight was such that within the Skyline Project area there was a bar or tavern for every 29 residents. There were 29 hotels, 14 boardinghouses, 12 apartment buildings, and 7 missions with 129 beds. The reality was that much of this area had to be cleared for redevelopment, but it cost the city some of its most outstanding architectural gems.

Capitol Hill faced the same plight. The neighborhood, once lined with the grand mansions of Colorado's early movers and shakers, became a neighborhood of cheap boardinghouses, drugs, prostitution, and unsafe streets. In the quest to revitalize the area, palaces crumbled, mansions were bulldozed, and marble walls and stained-glass windows became one with the landfill.

Both downtown and Capitol Hill have continued to change over the years and have thrived with those changes. With the opening of downtown's Sixteenth Street Mall in the early 1980s, which has attracted shoppers and new businesses during the past three decades, and with the ongoing revitalization of the Capitol Hill neighborhood and the discovery by new arrivals to the city that both downtown and Capitol Hill are attractive and diverse places to live and work, two of Denver's oldest areas face a bright future.

Preservation has been a dirty word over the years, mainly to developers, investors, and bankers, who misinterpreted it as a missing cog in the wheel of progress. This stance has softened considerably. DURA, which had the initial objective to clear out the old buildings of the center of the city, today works with city planners to incorporate vintage buildings into the modern scheme of things. The following are only representative examples of some of the many styles and timelines of the city's architecture.

One

HOTELS AND APARTMENTS

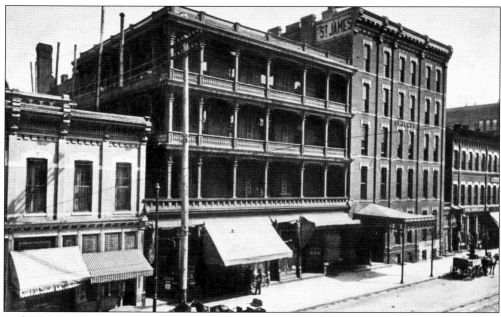

Early Denver was an unsettled city, and hotels rose on every block to meet the needs of dusty travelers. Apartment living became the norm downtown and later in Capitol Hill. Hotels such as the Grand Central and the Oxford were popular. Of the many apartments built downtown in the early days, virtually none exist today, along with few of the original hotels. Pictured is the St. James Hotel in the 1500 block of Curtis Street, now demolished.

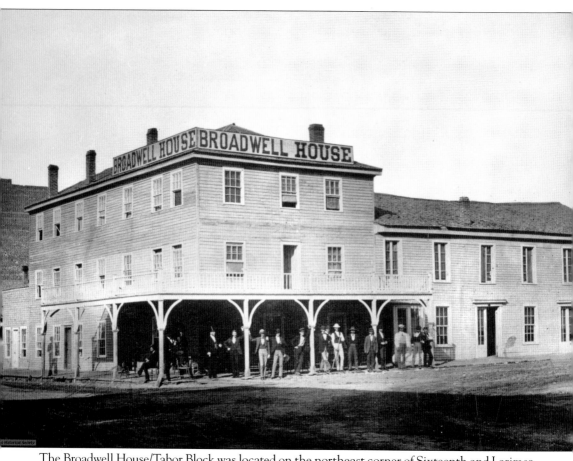

The Broadwell House/Tabor Block was located on the northeast corner of Sixteenth and Larimer Streets. The Broadwell, designed by architect Leonard Cutshaw, was built in 1859. The Tabor Block architects, Willoughby and Frank E. Edbrooke, saw their structure erected in 1880. One of Denver's earliest hotels, the Broadwell House became a popular meeting place for those in the horse and cattle trade and those traveling from the east on to California. An addition was built in 1871. Only when American House was built in 1869 did the Broadwell begin to lose its first-rate status. The same happened to American House when the Windsor Hotel opened in 1880. The Broadwell catered to a widely diverse clientele, from trappers and gold miners, to salesmen and politicians, to refined society. The hotel was well known for its fine food. A menu of the early days offered bean soup, bottled pickles, mountain trout, buffalo steak, venison, sage hen, plum pudding, and raspberry ice. Horace A. W. Tabor, the silver king from Leadville, purchased the Broadwell and had it demolished to make way for his impressive Tabor Block, also known as the Nassau Block. (Courtesy of the Colorado Historical Society.)

Hiring Willoughby A. Edbrooke as architect, Horace A. W. Tabor set out to build a solid monument to himself. Stone was quarried in Ohio. Massive iron posts gave support to the Tabor Block. This was at a time when many of the city's buildings were wood-frame structures lining unpaved streets. This was also a time of frenzied construction in the downtown area. (Courtesy of the Colorado Historical Society.)

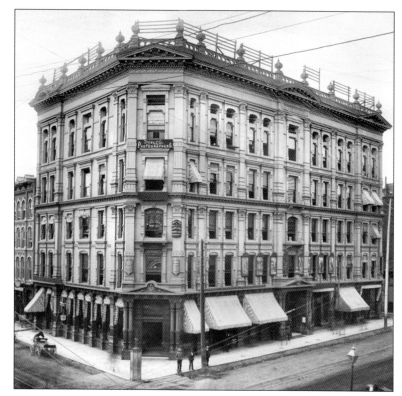

The Tabor Block had many firsts for Denver: the first elevator, the first building of six stories, and the first telephone company in the city, the Consolidated Telephonic Corporation. By the 1930s, however, the Tabor Block was struggling to stay afloat. By 1958, all but the first floor was closed. It was torn down in 1972. The namesake Tabor Center shopping complex (pictured here) was built on the site in 1984.

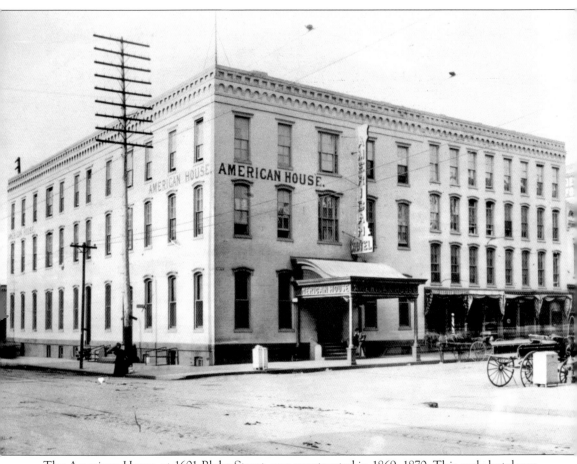

The American House, at 1601 Blake Street, was constructed in 1869–1870. This early hotel was built by John W. Smith, who had also purchased and managed the adjacent Inter-Ocean Hotel and the Red Lion Inn, which once occupied the land where the Sugar Building (built in 1906) stands today at 1530 Sixteenth Street. Considered Denver's first modern hotel, the American House played host to many distinguished visitors, including Pres. Ulysses Grant; Cyrus Field, who laid the first trans-Atlantic cable; and Grand Duke Alexis of Russia. The American House was outfitted with fine china, glassware, and silver, and was decorated with walnut furniture, plush curtains, feather mattresses, boot jacks, and metal bathtubs, which were filled by the head porter with hot or cold water from pitchers. The kitchen offered fare such as prairie chicken, buffalo tongue, trout, wild turkey, and antelope cutlets. The cellar held a large stock of imported wines and liqueurs, and the bar blazed at night with coal lamps fitted with polished tin reflectors. The bar included spittoons and billiard tables. The architect is unknown. (Courtesy of DPL.)

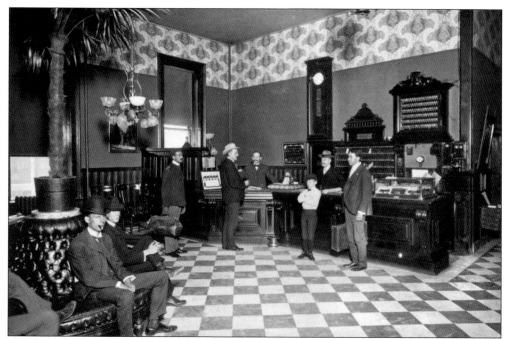

An early advertisement boasted: "Two hundred rooms, suites and apartments. Well ventilated. Lighted with gas. Telegraph from each room to office. First class in every department." It was reportedly the first building in the city to use steam heat. For 10 years the three-story American House was the largest hotel in the city, only to be outdone by the Windsor Hotel in 1880. (Courtesy of DPL.)

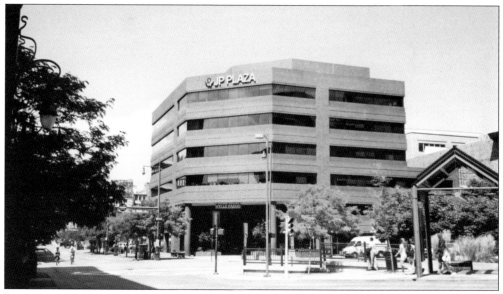

Increasing patronage necessitated an addition to the Blake Street side, but over the years, the hotel trade moved uptown, to the east. The American House was sold and used for storage, but the final blow came in 1933 when nearby Cherry Creek flooded and severely damaged the building. It was soon demolished and replaced with a filling station. The J P Plaza (shown here) occupies the site today.

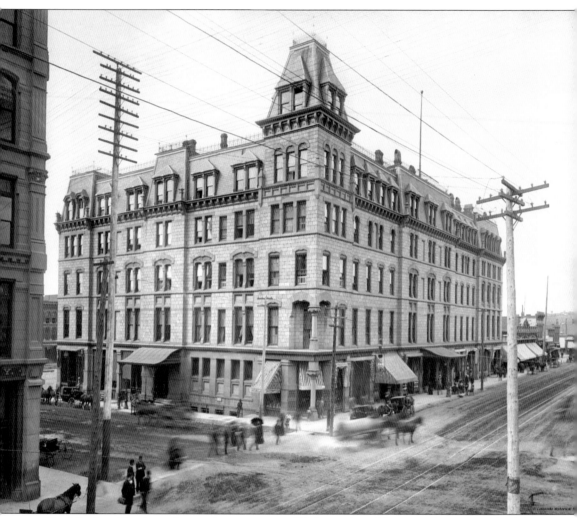

The Windsor Hotel, on the northwest corner of Eighteenth and Larimer Streets, was built by Denver Mansions Company, Ltd., in 1879–1880. The Windsor, financed by millionaire Horace A. W. Tabor, was one of the grandest and most up-to-date hotels in the West. The main building was 125 by 225 feet and 112 feet to the top of its tower. The exterior was faced with lava stone trimmed with red sandstone and finished with ornamental iron fretwork. The interior was lavish for the era and offered every modern convenience. The building was constructed around a central court, allowing light and air to reach almost every room. The hotel had an elevator (a luxury at the time) and two massive wooden staircases leading to the upper floors. The rooms were furnished with Brussels carpets in different designs, and chairs were stuffed with mohair and covered with silk plush. Each room had a rocking chair. The 176 rooms were almost all fitted with a marble mantle and iron grate, and marble-topped dressing tables. Each room was supplied with hot and cold water, another luxury. (Courtesy of the Colorado Historical Society.)

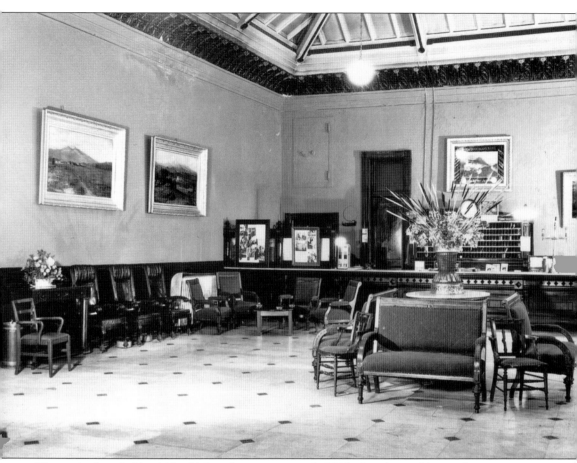

The main floor held a 44-by-84-foot dining room with 24 black walnut tables, each seating six. Four floor-to-ceiling mirrors cast light across the room, and three chandeliers of 12 burners each lit the room at night. The hotel offered an array of foods and beverages. There was an extensive wine list. The men could sample a large selection of cigars. The Windsor Hotel enjoyed great success for the first few decades of its existence. Famous guests included Mark Twain, Rudyard Kipling, Pres. William Taft, and Pres. Theodore Roosevelt. Horace Tabor and his second wife, Elizabeth "Baby Doe" Tabor, lived there for a time after he lost his fortune, and he died there in 1899. By the 1930s, the Windsor Hotel had lost its luster. Attempts were made to revive interest in the hotel, including a series of melodramas put on by the Windsor Players in the 1950s, but the hotel fell into disrepair. Its lobby, pictured here in 1945, was showing its age. The hotel was torn down around 1959. (Courtesy of DPL.)

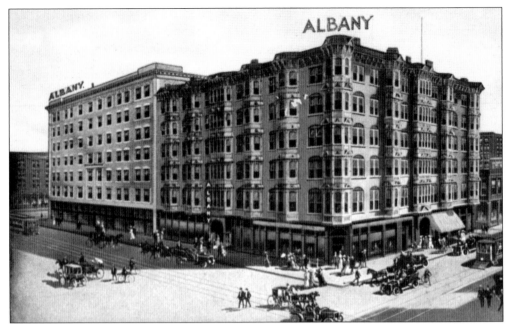

The Albany Hotel, at Seventeenth and Stout Streets, was designed by architect E. P. Brink and was built in 1882. The hotel was financed by W. H. Cox, a hotel man from Albany, New York. Boasting 155 rooms, the Albany Hotel quickly gained a reputation as an elegant hostel in a dusty cow town, and it was Cox's answer to the grand Windsor Hotel, built not far away only a short time earlier.

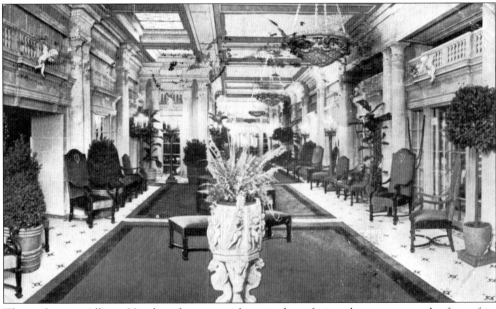

The multistory Albany Hotel, with its many bay windows facing the street, was the first of its kind in Denver to be completely equipped with electricity. Early guests included General Tom Thumb, mining engineer John Hays Hammond, and Horace A. W. Tabor. It was a stopping place for cattlemen and cowboys during the early days of the National Western Stock Show. Pictured is the Grand Promenade.

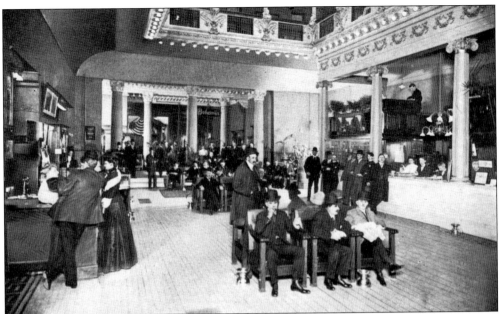

A $200,000 annex was built in 1906, measuring seven stories tall and adding 150 sleeping rooms to the hotel. With the addition of the annex and subsequent remodeling, there were now four main dining rooms with a total seating capacity of 500. A wide hall ran from the rotunda (shown here) east to a large banquet hall, measuring 50 by 70 feet, which featured a dance floor and a stage for an orchestra.

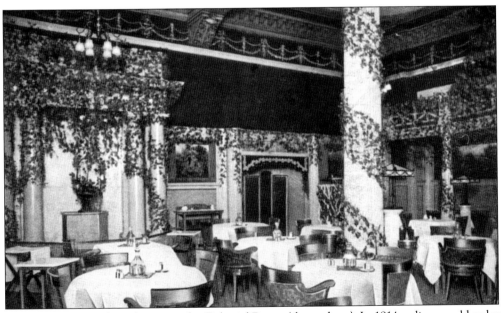

A dollar could purchase dinner in the Colonial Room (shown here). In 1914, a diner could order Lobster Newburg for 75¢ or sample caviar for $1.25. Sen. Thomas Patterson's family gained control of the hotel and, in 1938, ordered the old structure demolished. A new 333-room hotel was built in its place. The hotel flourished but was struggling by the early 1970s, and it was demolished in 1976.

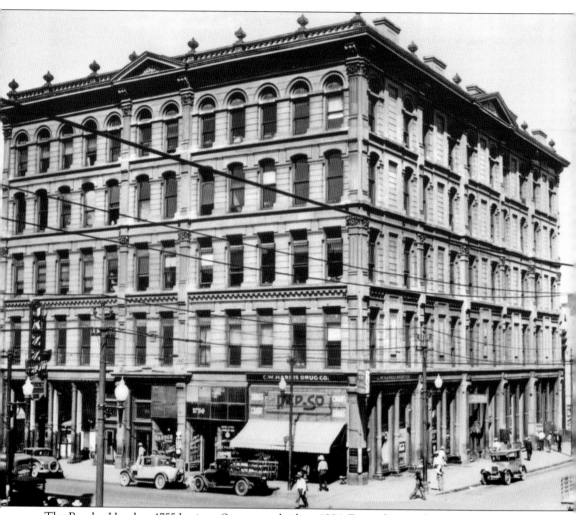

The Barclay Hotel, at 1755 Larimer Street, was built in 1884. Erected in an already bustling section of the city by the Denver Mansions Company, Ltd., the same British concern that had constructed the adjacent Windsor Hotel four years earlier, the Barclay quickly became a crowded gathering place. It housed the state legislature for eight years before the state capitol was constructed. There were comfortable rooms on the top floors, and a large dining room, common rooms, and shops on the main level. Elaborate marble baths were located in the basement, which were used by its guests and also patrons of the Windsor Hotel across the street. Walls of the baths were faced with polished marble and mahogany. Light filtered through stained-glass windows. There were different styles of baths, such as Turkish, Roman, and "Electric." There was also a special area for steam baths and a shampoo cubicle, and one large room contained a marble wading pool. Artesian water was piped in, and white-robed attendants were on duty to offer assistance. (Courtesy of DPL.)

Popular and relatively inexpensive, the Barclay was a welcome sight for the many tired and dusty travelers coming into Denver. Famous guests included Oscar Wilde, William H. Vanderbilt, and Pres. Theodore Roosevelt. After many successful years, the Barclay Hotel faced the same fate as similar downtown establishments. Struggling as a hotel through the 1920s and 1930s, it was turned into apartments for low-income tenants and eventually became so dilapidated that the city was forced to step in. The once-elegant baths were used for storage, strewn with old furniture, trash, and dirt. The hotel was offered for sale, but there were no buyers. In the late 1960s, the Denver Urban Renewal Authority pushed to bulldoze the Barclay. The Landmark Preservation Commission launched its own campaign to try to save it but failed. After a few more years as a flophouse, and after being cited repeatedly for city code violations, the Barclay was ordered closed and was torn down in 1970. A condo complex (pictured), built in 1981, occupies the site today.

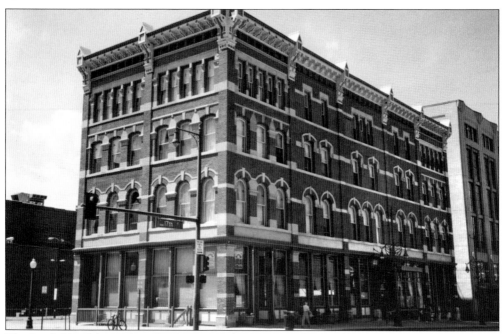

The Barth Hotel, located at 1514 Seventeenth Street, was designed by architect Frederick Eberley and was built in 1882. Moritz Barth parlayed a tiny shoe store into one of the great fortunes of 19th-century Colorado. He took his earnings and invested heavily in real estate. For a time, he was a secretary for the Colorado School of Mines in Golden. The four-story building was constructed to house the Union Liquor Warehouse at the corner of Seventeenth and Blake Streets.

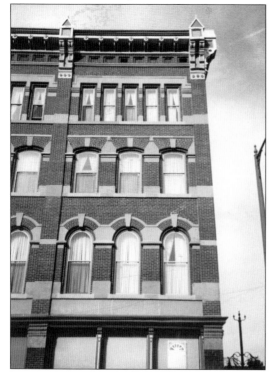

The building has an imposing facade, with windows on each floor designed in a different style. After only a few years, the Union Liquor Warehouse was closed. The building was turned into a hotel and was renamed the New Union. By the 1920s, it was called the New Elk Hotel, and in 1930, M. Allen Barth, Moritz's son and namesake, purchased the building, changing the name to the Barth Hotel.

M. Allen Barth purchased the hotel at the beginning of the Great Depression and soon lost the hotel to creditors. It began a long downhill slide. By the 1940s, it had a seedy reputation. For a time there was a bar off the main lobby, one as rough as any downtown in the days of Denver's urban blight. Somehow the Barth managed to escape urban renewal's bulldozers.

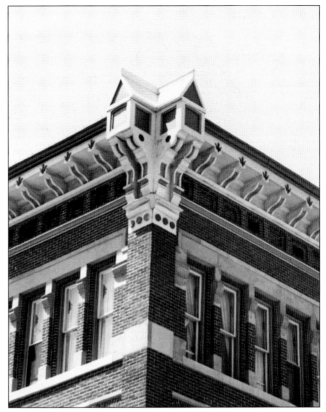

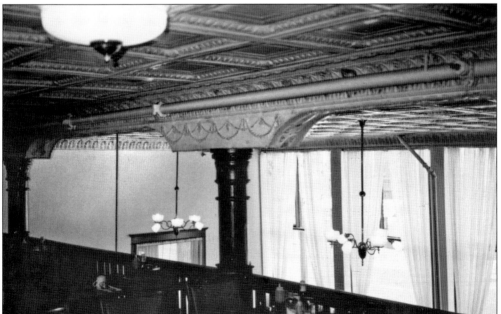

In 1980, Senior Housing Options, a charitable nonprofit group, bought the hotel and converted it into a residence for low-income and disabled people. The group then spent more than $1 million to bring the hotel up to city code, though many of the historic elements remain in place.

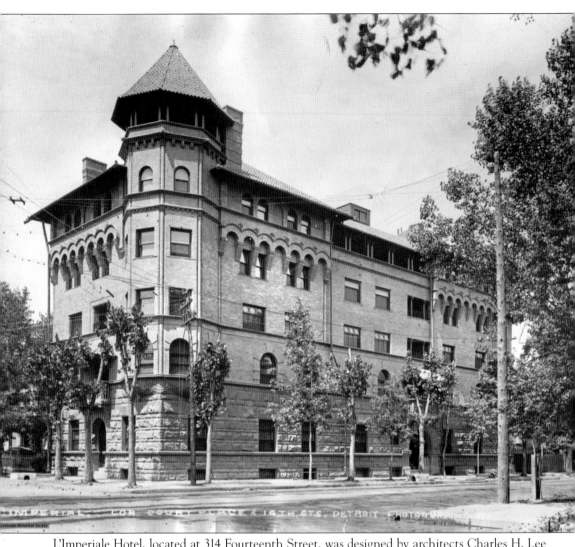

L'Imperiale Hotel, located at 314 Fourteenth Street, was designed by architects Charles H. Lee and Theodore Boal and was built in 1892. Denver's last word in quiet elegance had 85 rooms and was designed in the Tuscan style. The base was rusticated red sandstone, with the upper floors of beige pressed brick. Carved stone balconies graced the upper exterior, while inside were tiled and carved fireplaces in every room and hand-woven Turkish carpets throughout the rooms and halls. Two elevators carried guests to the top levels. The hotel offered numerous amenities, including an excellent dining hall, a casino, and a roof garden, but the hotel was never a financial success. It became an apartment-hotel around 1900, but even that was not enough to sustain it. L'Imperiale eventually closed and was reopened as medical offices. It subsequently became headquarters for the Community Chest, which was to evolve into the United Way. The building was empty by 1962 and was demolished a year later. The site has since been used for parking. (Courtesy of the Colorado Historical Society.)

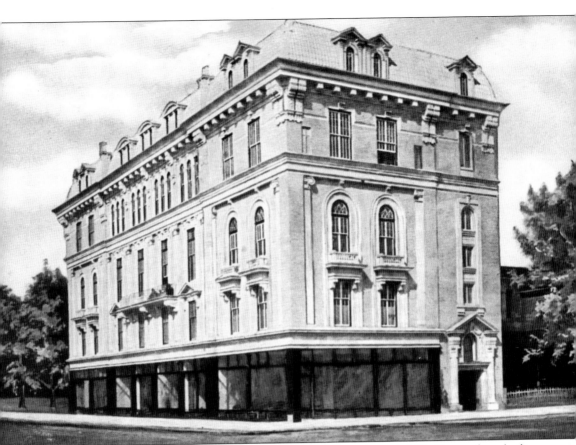

Fraternal Hall, located at 1405 Glenarm Place, was designed by architect J. J. Huddart and was built in 1908. This four-story structure, later called the Knights of Columbus Hall, was constructed for what is now the largest Catholic fraternal organization in the world. The Knights of Columbus was organized in Denver in 1900 and met in a number of locations before moving into the Glenarm Place building. Lodge quarters were on the third floor, with an assembly hall on the top floor. A variety of retail shops were on the street level. The building was sold in 1920 to the Knights of Pythias. The Knights of Columbus moved into the Donald Fletcher mansion at Sixteenth Avenue and Grant Street. Although the mansion was demolished years ago, the organization remains in a newer building to the south. The Glenarm Place building was later used for labor union meetings and, in 1947, housed the extension center for the University of Colorado. The building's last tenant was Collin's Finer Foods. It was torn down in 1962.

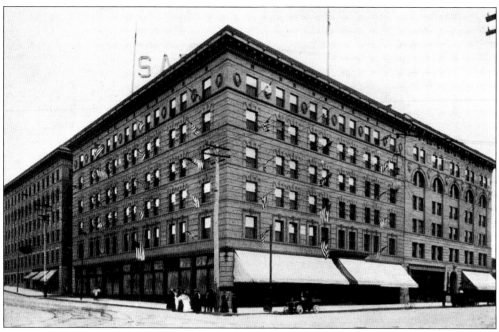

Shirley-Savoy Hotel, located at Seventeenth Avenue and Lincoln Street and Seventeenth Avenue and Broadway, was designed by architects Willis Marean and Albert J. Norton and was built in 1902–1903. In 1902, David Dodge and Walter S. Cheesman, both Colorado pioneers, saw a need for luxury hotel accommodations at reasonable rates. Denver was a growing city and rapidly gaining respectability. Work was started on Dodge's Shirley Hotel at Seventeenth and Lincoln Streets, which opened in 1903.

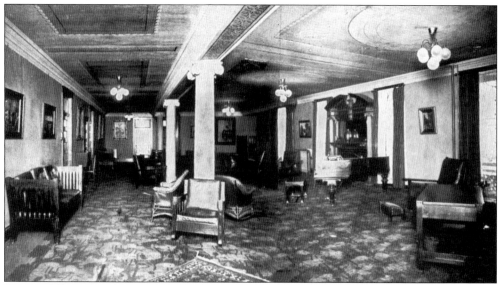

Soon to follow was Cheesman's Savoy Hotel, at Seventeenth Avenue and Broadway. Dodge also built the Shirley annex, south of the Savoy, which became offices for the Denver Union Water Company, of which both Dodge and Cheesman were involved. The annex later became part of the Shirley-Savoy complex. In 1921, Dodge bought out Cheesman's half, and the complex then became known as the Shirley-Savoy. The hotel boasted more than 400 rooms.

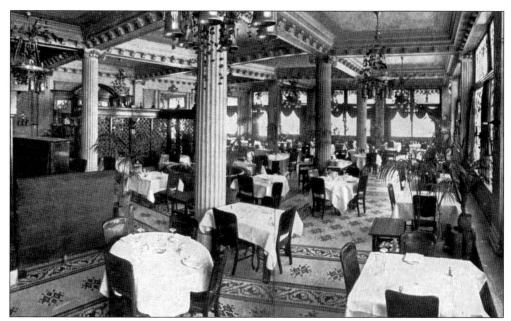

The hotel was a magnet for cattlemen and out-of-state legislators. Pictured is the main dining room around 1910. In 1937, work began on the Lincoln Building, a large meeting hall adjacent to the Shirley. It soon became a center for conventions and banquets. The Shirley-Savoy and the annual National Western Stock Show became almost synonymous. For 10 days each January, more than 1,000 ranchers and cowboys took over the hotel.

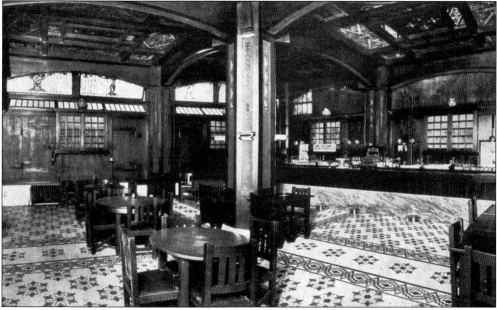

In 1962, the properties were split. The Savoy, housing the lobby, tavern, and dining room, continued to operate as a hotel. The Shirley, the Lincoln Building, and the Shirley annex were slated for destruction that same year. The Savoy was torn down in 1970, and construction of Columbia Plaza commenced. The former Shirley Hotel site is now a parking garage. Pictured above is the Indian Grill around 1905.

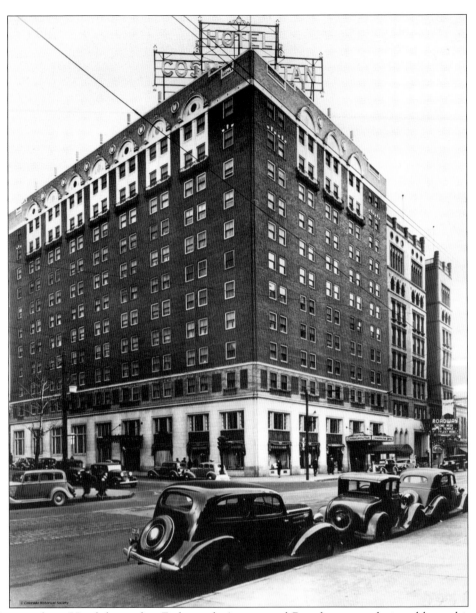

Cosmopolitan Hotel, located at Eighteenth Avenue and Broadway, was designed by architect William Bowman and was built in 1926. When the Cosmopolitan Hotel opened in the summer of 1926, it annexed the Metropole Hotel next door. Billed as the "most complete" hotel in the city, more than 5,000 people wandered through the "Cosmo's" common areas on its first day. The hotel's rooms filled up quickly. Guests roamed the broad lobby, peered into the dining room and the lounges, and relished the scent of the more than 100 floral arrangements decked throughout the main floor. When the hotel opened, it featured sizeable space for conventions and fine dining for local and out-of-town guests. It employed more than 400 people. A banquet room called "the Hall of Colorado" was a ballroom/dining room that featured wall murals depicting the history of the state from the days of the Gold Rush through the early 1900s. The Cosmopolitan played host to politicians, heads of state, movie stars, writers and artists, and many tourists. (Courtesy of the Colorado Historical Society.)

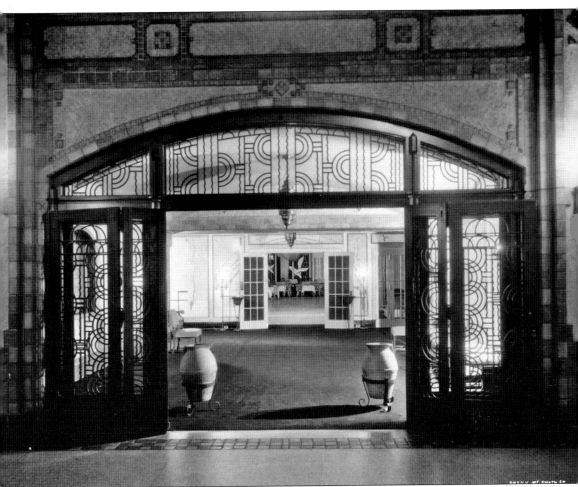

The first floor and mezzanine covered an area measuring 250 by 100 feet. The upper floors contained 285 rooms. The interior, pictured about 1930, was the last word in elegance. A lobby, a ballroom, a kitchen, and shops were located on the main floor. The lobby was two stories high, with a floor of terrazzo with a marble border. Off of this area were the dining room, the Columbine Gallery, lounges, elevators, and stairways. In 1952, the hotel was completely remodeled, bringing the old building up to par with "modern" Denver. The Outrigger was a popular hotel restaurant with a Polynesian flair, part of Trader Vic's Restaurant. By 1984, the Cosmopolitan Hotel was struggling, outdone by newer and larger hotels. It was finally reduced to a huge pile of rubble by several well-placed explosives. The roof hit the ground in six seconds. (Courtesy of DPL.)

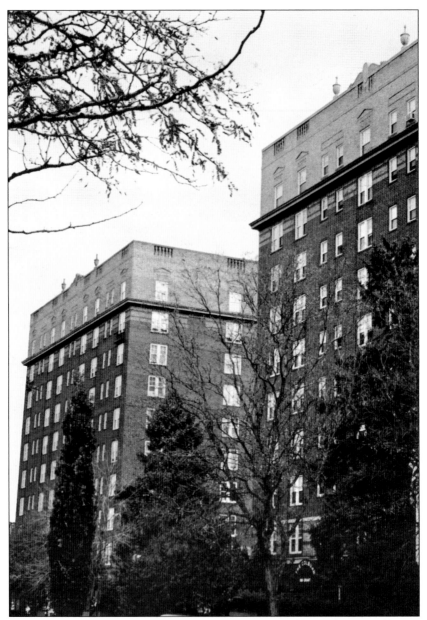

The Colburn Hotel, located at 980 Grant Street, was designed by architect William Bowman and was built in 1925–1928. The Colburn Hotel was Capitol Hill's first "high-rise" building, with the top floors giving a breathtaking view of the city below. The builder was Judge Ernest Colburn, who made his fortune in the Cripple Creek gold mines. The hotel originally catered to an upscale clientele. Construction began in 1925, but the hotel was not completed until 1928 due to financial difficulties. It was an immediate success, and as a result, it was decided to build a twin structure just to the south. The Colburn Apartments opened in 1930. It was apartment living at its best, with room service, laundry service, and dining facilities on the main floor. The Colburn Hotel emerged as the surrounding Capitol Hill mansions of a generation earlier were being wrecked or converted for private schools, apartments, and boardinghouses. (Courtesy of a private collection.)

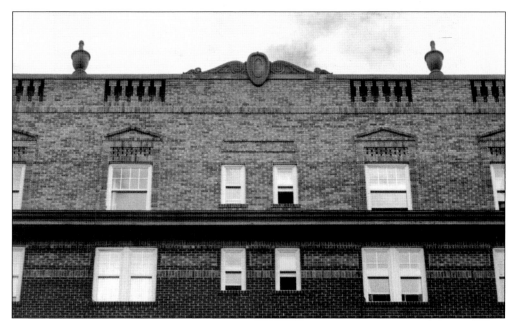

Judge Colburn sold the buildings during the Great Depression. The new owners struggled to keep things afloat. As newer and better hotels and apartments were built in the area, the Colburn's business slowly declined. A major renovation in the early 1980s did little to revive the sagging business. The hotel struggled, while the apartments were turned into a homeless shelter in the early 1990s. (Courtesy of a private collection.)

Jack Kerouac and Neal Cassady reportedly spent time together in the hotel's bar in the summer of 1947, and their friend, Beat poet Allen Ginsberg, reportedly lived briefly at the Colburn until finances forced him to move to the Brinton Terrace at Eighteenth Avenue and Lincoln Street. The Colburn is again a hotel and apartments. (Courtesy of DPL.)

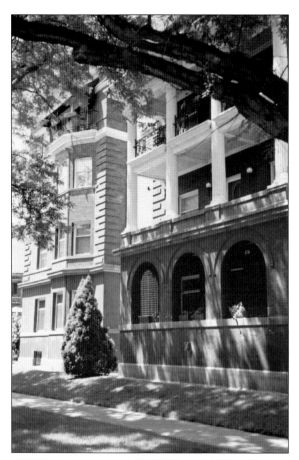

The Perrenoud, located at Seventeenth Avenue and Emerson Street, was designed by architect Frank Snell and was built in 1901. One of Denver's best kept secrets, the four-story Perrenoud was one of the most ambitious and elegant apartment buildings of Denver's early days. It was built by the Perrenoud sisters, Louise, Zelie, and Adele. The exterior design, which is somewhat plain, of pressed red brick and cut stone, belies the opulence of the interior spaces.

There are six wings and four courtyards. Originally there were 24 apartments, ranging from five to eight rooms each. The Perrenoud was equipped with telephone service whereby each tenant could contact other apartments in the same building or any of the janitors or attendants on duty. There was a freight elevator and a dumb waiter to carry supplies from the basement to each apartment.

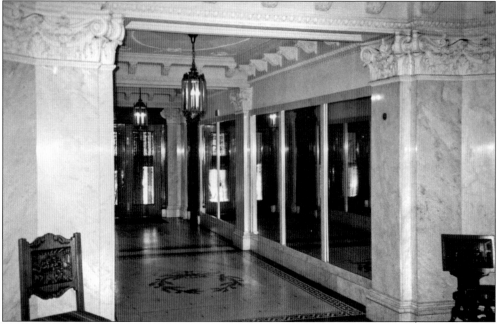

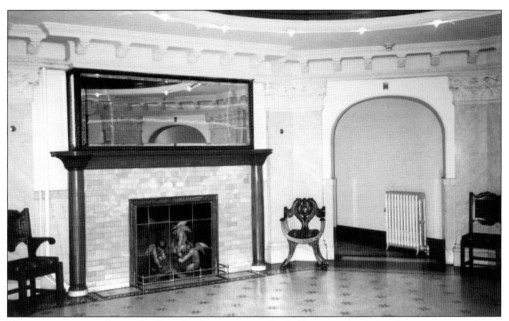

There once was a dining hall in the basement and a ballroom, which has been converted to a gym. The entrance hall is the main feature of the building. A luxurious corridor of Italian marble, lined with floor-to-ceiling plate-glass mirrors, leads to a central atrium (shown here), topped by a circular stained-glass dome. The still-operable birdcage elevator is the only unaltered one remaining in Denver.

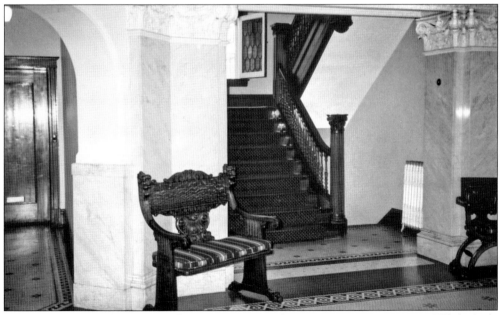

In the early 1950s, the Perrenoud became Denver's first co-operative apartment. While fairly common on the East Coast, co-operatives were virtually unheard of in the West. The tenant does not receive a deed but instead owns a percentage of the entire building, thus acquiring some say in not only how things are run, but also who is allowed to live there. In 1986, the Perrenoud was converted to condos.

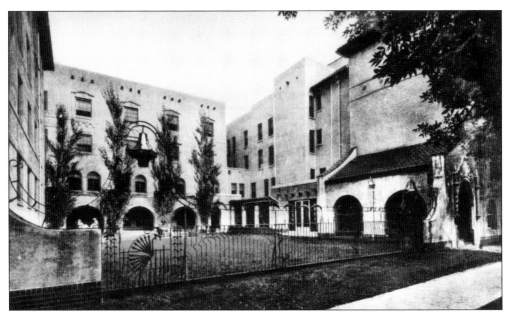

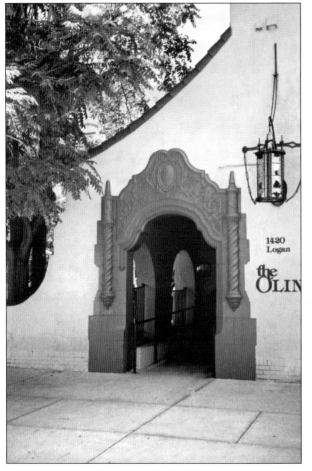

The Olin Hotel, located at 1420 Logan Street, was designed by architect James Manning and was built in 1925. Designed in the style of a Spanish mission, with its open court in the front, and reminiscent of many of the 1920s buildings of Los Angeles and San Diego, the Olin Hotel was originally a distinctive residential hotel when Capitol Hill was a genteel neighborhood. Built and managed by John O. Huntington, it had its own restaurant, seating 200.

The hotel was so successful that an addition was soon built. The lobby was decorated with tapestries, oriental carpets, Spanish-style furniture, and a grand piano. Lighting fixtures were fashioned of wrought iron, brass, and copper. A large dance floor was located on the main level, with music provided by the hotel's own orchestra. The immediate area surrounding the Olin was already dotted with hotels, and only a few remain.

In the 1960s, Olin management opened the Peppermint Cave, a popular club when the Twist was the newest dance craze. The Olin saw hard times in the 1970s, as did the area in general. Colfax Avenue, a half block north, had a notorious reputation as a hangout for prostitutes and drug dealers. Hippies contributed to the transient character of the neighborhood.

Operated under the auspices of Senior Housing Options, the old hotel, now called the Olin Hotel Apartments, provides housing for low-income seniors and the disabled. Trinity Church, ministering in Denver continually since 1888, hosts an annual Christmas party at the Olin, with its parishioners providing gifts from its wish list for more than 100 Olin residents.

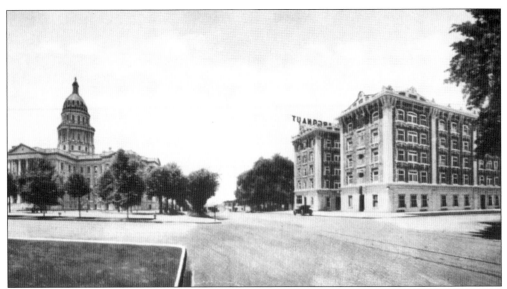

The Argonaut Hotel, located at East Colfax Avenue and Grant Street, was designed by architect T. Robert Wieger and was built in 1913. The Argonaut replaced an earlier residence. When it opened, the hotel offered sumptuous meals in its dining rooms. A complete dinner cost $1.25. There were accommodations for banquets and teas. Dancing was accompanied by the hotel's orchestra. (Courtesy of a private collection.)

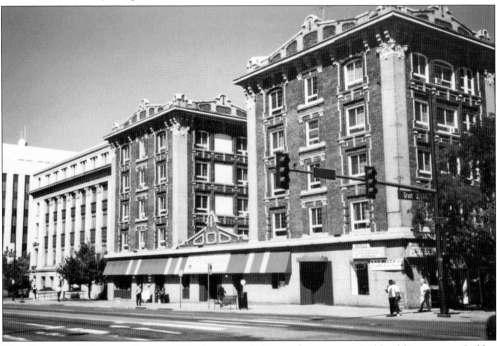

The Argonaut's claim to fame was its close proximity to the state capitol building across Colfax Avenue. Legislators and out-of-town politicians met regularly at the Senate Lounge. Pierre Wolfe's Quorum Restaurant was a popular meeting place for years. The hotel eventually hit rough times, as did that general area of Capitol Hill. The hotel closed in the 1970s, and the building functions now as low-income residences. (Courtesy of a private collection.)

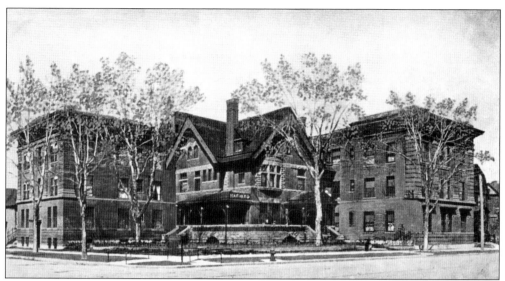

The Harvard Hotel, located at 501 East Colfax Avenue, was built around 1890. Colfax Avenue was once lined with the stately houses of the wealthy from Broadway east to York Street. Over the years, most of them were torn down or converted to hotels and apartments. The Harvard Hotel was among a string of such places. It has been gone for 50 years. A fast food restaurant sits on the site today.

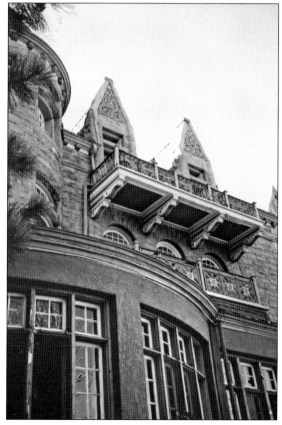

Charline Place, located at 1421–1441 Pennsylvania Street, was designed by architects Ernest Varian and Frederick Sterner and was built in 1890. Originally constructed as exclusive townhouses, Charline Place was converted to apartments in 1902 by its owner, Charles Smith. The building has had a checkered past. Remodeled a number of times, it has been converted to condos, as have many older apartments and townhouses in the Capitol Hill neighborhood.

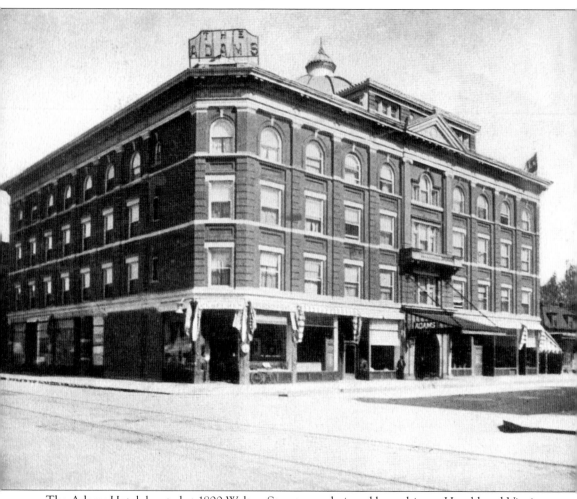

The Adams Hotel, located at 1800 Welton Street, was designed by architects Harold and Viggio Baerrensen and was built in 1902. Long a Denver landmark, the Adams Hotel was once one of the busiest and most popular of the downtown hotels. It was compared to the Brown Palace Hotel for its amenities and appeal as a first-class establishment. Originally each room had its own color scheme, following through with the walls, carpeting, and drapes. A popular feature was the Dutch Room, with its Flemish oak paneling and large stained-glass window with a windmill scene. The hotel was five stories high and was topped with a copper dome under which was the Palm Room, measuring 55 by 60 feet, with walls covered with French tapestries. The dome rose 25 feet in the center of the room. Electric bulbs lit the circumference of the dome. The building featured Denver's first push-button elevator and another innovation: telephones in every room. The Adams Hotel closed its doors in the 1960s, and the dilapidated ruins of a bank drive-thru occupy the site today.

Two

COMMERCIAL AND GOVERNMENT BUILDINGS

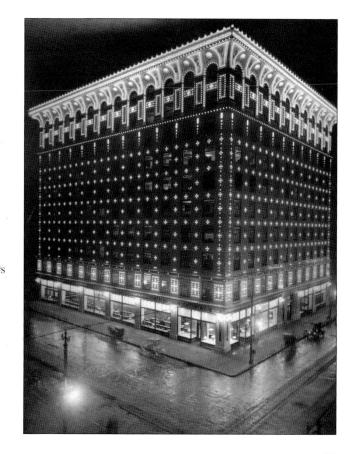

There are still many outstanding examples of early Denver architecture throughout the city, but the damage wrought by urban renewal in the 1950s and 1960s is irreplaceable. Ironically, the warhorses of the lower downtown commercial district have mostly survived, primarily warehouses and other utilitarian spaces that have always paid their way. At right is the still-standing Gas and Electric Building, built in 1910 at Fifteenth and Champa Streets.

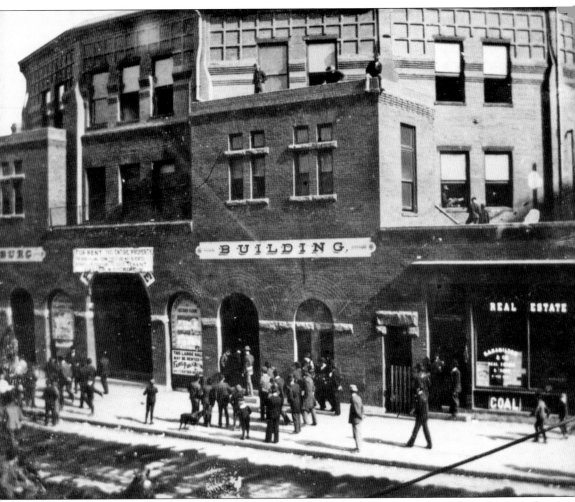

The Gettysburg Building, located at 1716 Champa Street, was constructed in 1885. This round, three-and-a-half-story building was originally built to house a cyclorama of the Battle of Gettysburg. The structure was constructed in a large circle with a pointed dome ceiling topped with a small cupola. The street front was in block form, with many arched windows and doorways. The display featured a few hundred feet of painted canvas attached to the walls in a 360-degree display. It did not revolve. Instead, the viewer walked the length of the canvas to view the entire piece. Described in the *Denver Republican* newspaper as "a striking presentation of one of the greatest battles ever fought. It was great in the number of men engaged and greater yet in its results. It was one of the decisive battles of the world." Cycloramas were tremendously popular in the last half of the 19th century, and many were displayed periodically throughout the country. Denver was no exception, and huge crowds showed up to view the massive display. (Courtesy of DPL.)

In 1888, a representative of the Chinese government purchased the painting, and the canvas was dismantled and shipped to China via San Francisco. The fate of the canvas is not known. The following year, the interior of the Gettysburg Building was completely remodeled for use as a U.S. post office. The new post office employed about 100 people but remained in the building for a relatively short time. By the early 1890s, the building was used for a variety of purposes, including a popular waxworks exhibit, charity events, union meetings, lectures, and ice-cream socials. The building burned to the ground in 1905. The Gettysburg site was taken up by the former Denver National Bank, the Chamber of Commerce, and Buerger Brothers Buildings, pictured here. All are still standing.

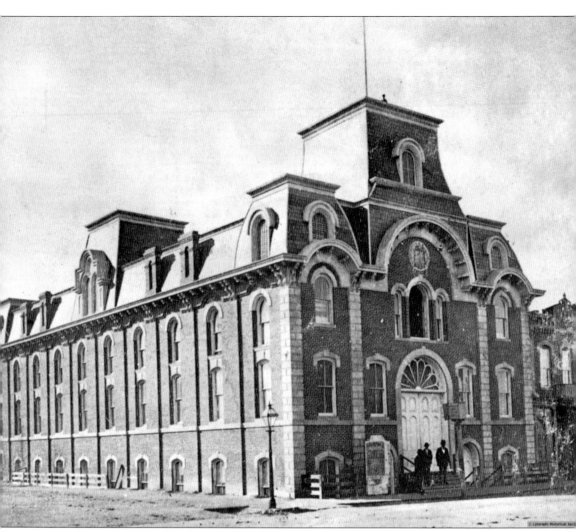

Guard's Hall/Forrester Opera House, located on the southwest corner of Fifteenth and Curtis Streets, was designed by architect Emmett Anthony and was built in 1873–1874. This great pile of Victorian whimsy was constructed as a public meeting hall and an armory for the governor's guards. A small stage was soon added, and some dramatic performances were given, but the building did not pay for itself, and it was soon sold to Cyrus Strong of New York. For a short time, the lower half of the building was used by the Colorado School of Mines. In 1876, Nick Forrester bought the building and remodeled the structure for use as an opera house and music hall. Under his management, some national names were brought in, and a wide variety of entertainment was offered. Plays and musicals included *Our Girls*, *The Drunkard*, *Bertha the Sewing Machine Girl*, *Pink Dominoes*, and *Uncle Tom's Cabin*. Boxer Joe Jefferson appeared in a production of *Rip Van Winkle*, and Edwin Booth, brother of John Wilkes Booth, Lincoln's assassin, starred in Shakespeare's *Hamlet*. (Courtesy of the Colorado Historical Society.)

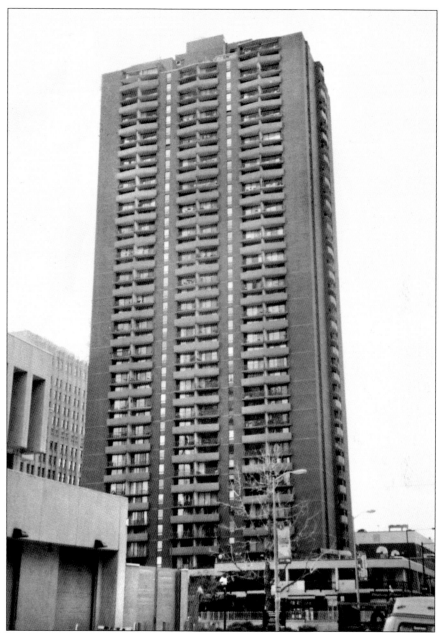

While it was common practice for audience members to show their displeasure in a performance by booing and throwing eggs and vegetables at the stage, the theater was grappling for more civilized behavior. The old armory closed in 1880, and the building was torn down, replaced with a row of one-story retail stores. In 1966, construction began on the high-rise Brooks Towers complex, which was slated to take up the entire block bounded by Fourteenth, Fifteenth, Curtis, and Arapahoe Streets, replacing the old Guard's Hall site. The Mining Exchange Building, just west at Fifteenth and Arapahoe Streets, a landmark for years, was torn down, as well as buildings on the rest of the block. The Brooks Towers (pictured), built as a retail and apartment complex, was the first major apartment building constructed downtown in decades and was instrumental in reintroducing Denverites to downtown residential living.

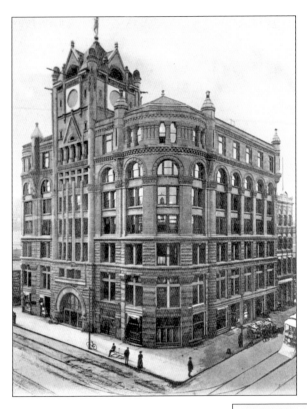

The Mining Exchange Building, located at 1030 Fifteenth Street, was designed by architects Kirchner and Kirchner and was built in 1891. One of Denver's most famous icons was barely visible from the street. The colossal statue of a miner that stood atop the lofty, three-story clock tower of the Mining Exchange Building 160 feet above the sidewalk was, for all intents and purposes, a symbol of the money that helped build the foundation of the city of Denver.

From the gold panning along Cherry Creek in the late 1850s, to mining and dredging in the hills above Denver in places such as Leadville, Cripple Creek, Central City, and Breckenridge, much of Denver's foundation was built with the gold and silver that came out of the mountains of Colorado. The Mining Exchange Building was constructed expressly for the purpose of mining activities. (Courtesy of the Colorado Historical Society.)

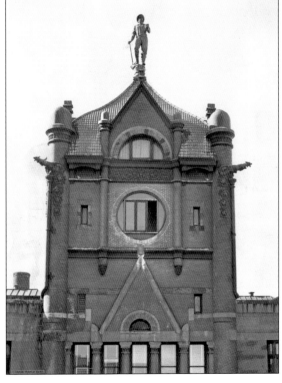

The structure, seven stories plus the tower, was built of rusticated stone with carved decorations and gargoyles. It was Colorado's first steel-frame building. The main entrance, a massive stone arch, was decorated with a life-sized bull's head on one side and a bear's head on the other. (Courtesy of the Colorado Historical Society.)

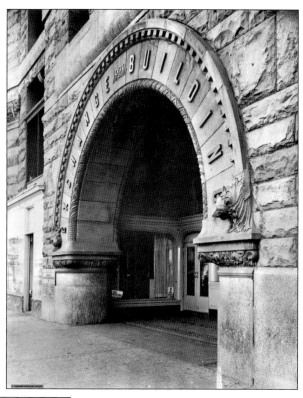

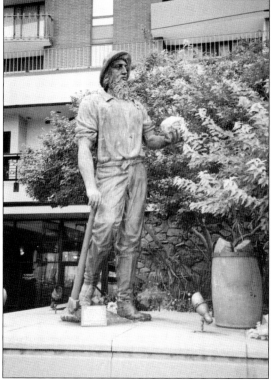

The supersized statue of the miner, named *The Old Prospector*, was reportedly modeled for by John William Straughn, who operated a blacksmith shop in Black Hawk, Colorado. The 12-foot-tall, 500-pound statue was executed in sheet copper by sculptor Alphonse Pelzer. It now stands proudly at the entrance of the Brooks Towers, the retail and residential complex that replaced the Mining Exchange Building in the early 1960s.

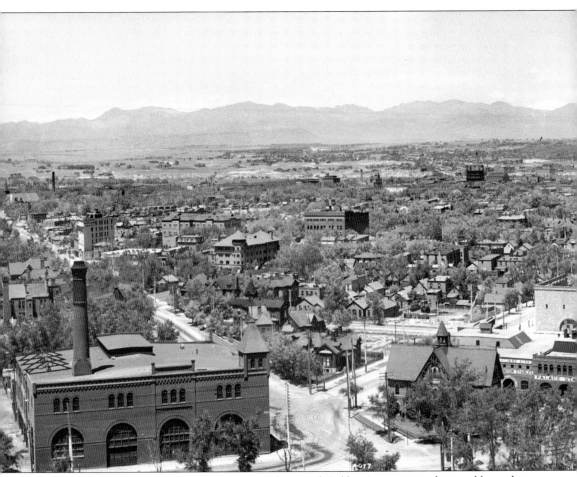

The Tramway Power House, located at Broadway and Colfax Avenue, was designed by architect Frank Edbrooke and was built in the early 1880s. Few people today are aware that Denver once had its own cable-car system. The earliest public transportation had been the horse-drawn streetcars, established in the early 1870s. Those were joined by the cable-car system in the 1880s. The powerhouse for the cable cars was a brick building at the southwest corner of Colfax Avenue and Broadway. In 1886, William Gray Evans incorporated the Denver Tramway Company, along with William Byers, owner and editor of the *Rocky Mountain News*, and other investors. The Denver Tramway Company, with its new electric-powered cars, essentially put an end to both the horse-drawn streetcars and the cable-car system. By 1900, the Denver Tramway Company had a virtual monopoly over the public transportation system of Denver and its suburbs. As a result, there was no longer a need for a cable power operation. It was decided that the old powerhouse be converted to store fronts and a warehouse. (Courtesy of the Colorado Historical Society.)

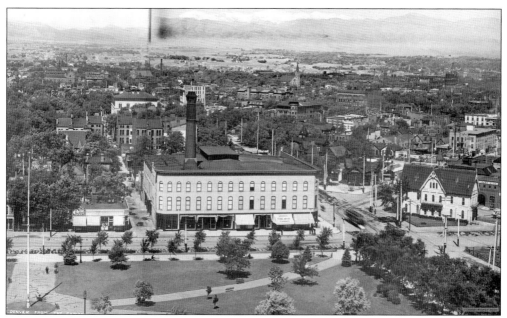

Around the time of this conversion, the rest of the block and the block just west had already been built up with residences, storefronts, apartments, houses, and duplexes. There had long been discussions during Mayor Robert Speer's administration of turning the area into a park and municipal center. Plans were formulated as early as 1904 but then stalled. (Courtesy of the Colorado Historical Society.)

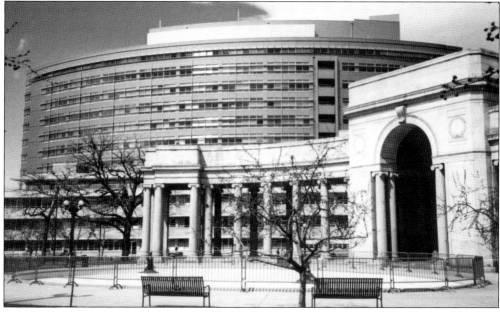

In 1912, however, demolition began on all the existing structures in a two-block area. The land was redesigned as public open space. The construction of the Greek Amphitheater on the south border and the Voorhies Memorial to the north (shown) essentially completed the new Civic Center park, just west of the state capitol building. Pictured also is the sleek Denver Newspaper Agency Building.

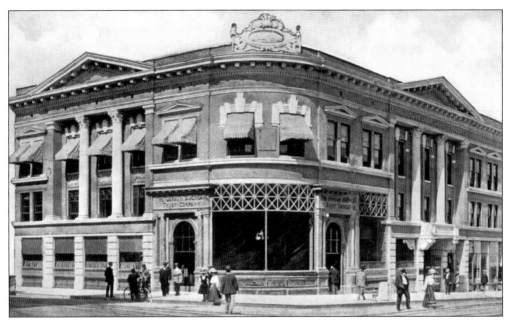

The German-American Trust Company, located at 1200 Seventeenth Street, was designed by architects Montana Fallis and John J. Stein and was built in 1908. This impressive corner-lot building was codesigned by Montana Fallis, whose other works included the Oxford Hotel annex at 1624 Seventeenth Street, the Buerger Brothers Building at 1732–1740 Champa Street, and the Mayan Theater at 110 Broadway, all still standing. The German-American Trust Company was founded by Godfrey Schirmer in 1905.

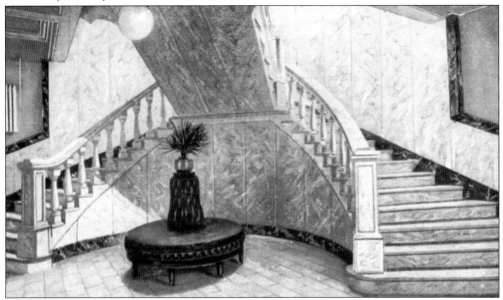

The bank's first offices were located in the Inter-Ocean Hotel at 1560 Blake Street. The business grew substantially in the first few years, and a new building was constructed at Seventeenth and Lawrence Streets. In its first months of occupancy, the bank used only a portion of the building but soon took over the entire ground floor. Its interior conveyed the restrained elegance of the early 1900s.

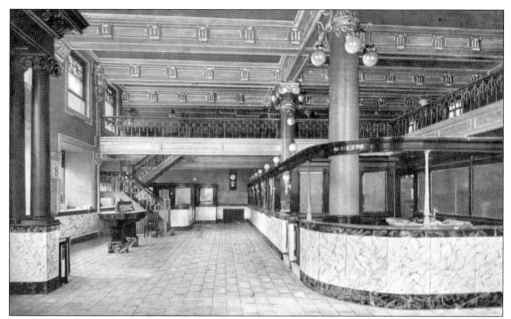

Business grew steadily through the next decade, but as a result of anti-German sentiments at the start of World War I, there was a run on the bank. As a result, the bank's name was changed to the American Bank and Trust Company. In 1924, the bank attained a charter from the U.S. Treasury Department and became a national bank under the name American National Bank.

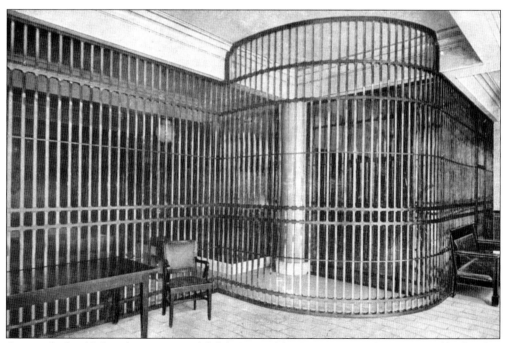

Among the bank's first directors were Adolph Zang, of the Zang Brewing Company, and his brother Philip. The bank eventually vacated the building, and it was demolished. Major construction in the area ensued, and the former site of the German-American Trust Company is now part of the Tabor Center retail complex.

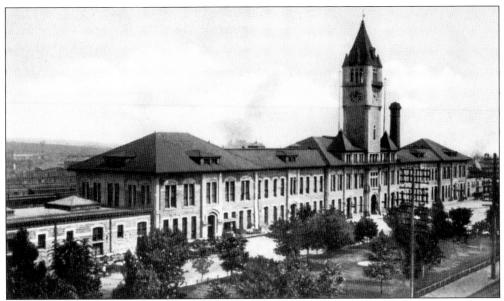

The Union Station, located at Seventeenth and Wynkoop Streets, was designed by architect A. Taylor and was built in 1880–1881. The first train station was constructed in Denver in the late 1860s to service the Denver Pacific Railway line. A decade later, there were four railroad stops in the city. One large station was created by the Union Pacific Railroad Company so that different rail lines could meet at a central point, making embarking and transferring easier on rail passengers.

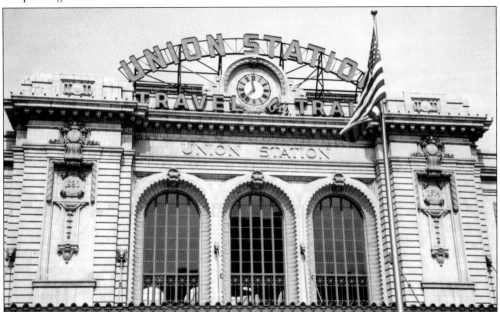

The new Union Station was built at Seventeenth and Wynkoop Streets. It was designed in the then-popular Italianate style, with a steep roofline and narrow vertical windows. Constructed of rusticated stone, it seemed impervious to disaster, but in 1894, a major fire destroyed the center section of the building, including the clock tower. This section was replaced with a new one, including a new clock tower, pictured at top.

By 1912, rail traffic had increased to the point that the center section had to be razed and replaced with a larger building. While the old wings remained, a new center section was erected in the Beaux-Arts style, designed by Denver architects Aaron Gove and Thomas Walsh, shown opposite bottom. It was designed with high, arched windows and an open central area surrounded by tickets offices and information booths.

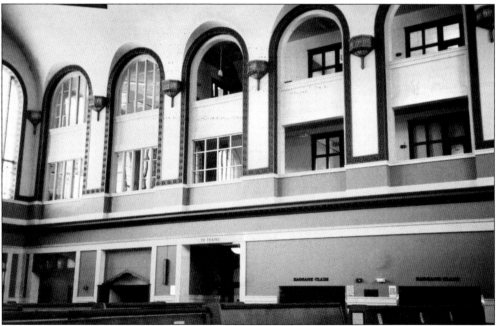

While passenger rail travel has decreased over the years, the Union Station still operates daily, mostly to accommodate Amtrak and Denver's light-rail system. The Denver Society of Model Railroaders meets in its basement. The Union Station sits in an area of expansive development throughout the Platte Valley and continues to be a major landmark.

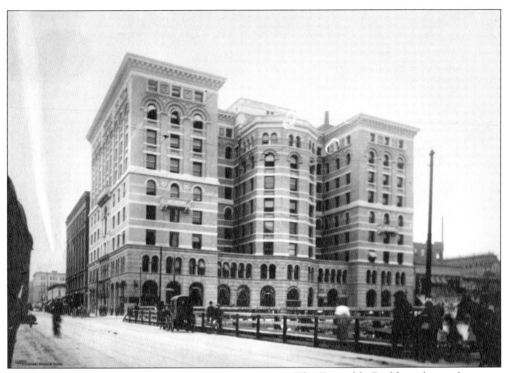

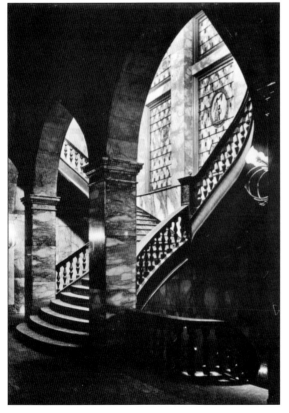

The Equitable Building, located at 730 Seventeenth Street, was designed by architects Andrews, Jaques, and Rantoul and was built in 1892. Denver's first high-rise, the Equitable Building towered nine stories over Seventeenth and Stout Streets in what was to become the center of the downtown financial district. Built by the Equitable Life Insurance Company, it was the most expensive building to be constructed in the city up to that time and also the tallest. (Courtesy of the Colorado Historical Society.)

Conceived in the Italian Renaissance Revival style and built of brick, granite, and terra-cotta, the building is a commanding presence along Seventeenth Street. The three-arched entrance leads to a long, polished onyx lobby with a vaulted ceiling. An elaborate staircase, lined with heavy brass railings, leads to the upper floors. Showcased on the landing is a large Tiffany stained-glass window. (Courtesy of DPL.)

An aerial view of the building shows that it was designed in the shape of an "E." The upper floors originally held offices for attorneys, mortgage brokers, mining executives, insurance brokers, and coal dealers. Many of Denver's early movers and shakers had offices there, including mining tycoons John F. Campion and Herbert Collbran, investment banker William Iliff, and attorneys William Vaile and William W. Grant Jr.

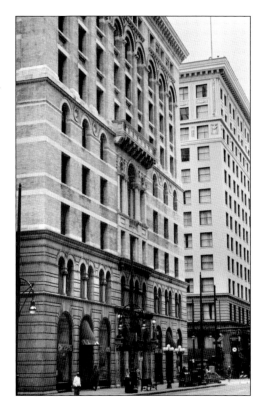

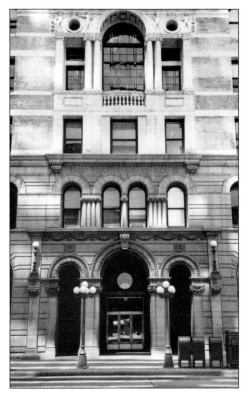

The Equitable almost immediately fell on hard times as a result of the Silver Panic of 1893. William Barth, a capitalist who had ties to Denver's Barth Building and Barth Hotel, purchased the Equitable Building in 1908. Since that time, the building has changed ownership a number of times as Denver moved further into modern times. (Courtesy of DPL.)

51

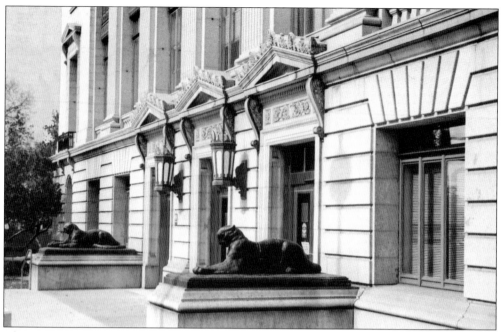

The State Office Building, located at 201 East Colfax Avenue, was designed by architect William Bowman and was built in 1921. This building, constructed just east of Colfax Avenue and Broadway, replaced the two-story residence of William N. Byers (1831–1903), who had launched Denver's first newspaper, the *Rocky Mountain News*, in 1859. The building's entrance is flanked by two bronze lions by sculptor Robert Garrison.

The architect relied heavily on Beaux-Arts influences in the decoration of the interior, resulting in an awe-inspiring effect of vaulted ceilings, arches, polished floors, and sweeping stairways. In a style that is both austere and solid, the facade belies the richness of the interior spaces. The State Capitol Building sits directly south, across Colfax Avenue.

The lobby is constructed of polished stonework and heavy plaster ornamentation along the walls and ceiling. It is lit by two large bronze and stained-glass chandeliers and several bronze wall lamps. Open balconies surround the second floor. The lobby is capped with a stained-glass skylight. The floor is light-and-dark marble in a checkerboard pattern.

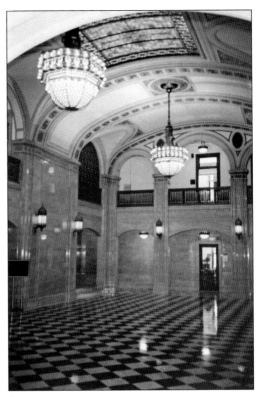

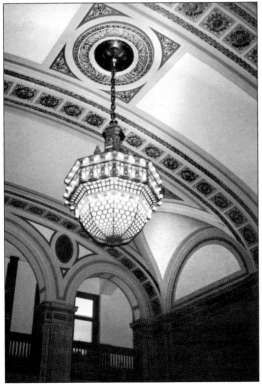

The interior is reminiscent of some of the lavish early movie palaces downtown, particularly the Denver Theater, a William Bowman design. The State Offices Building, which sits in close proximity to others mentioned in this book, such as the El Jebel Shrine Temple, the Capitol Life Building, the Central Presbyterian Church, and the University Club, now houses offices for the Colorado Department of Education.

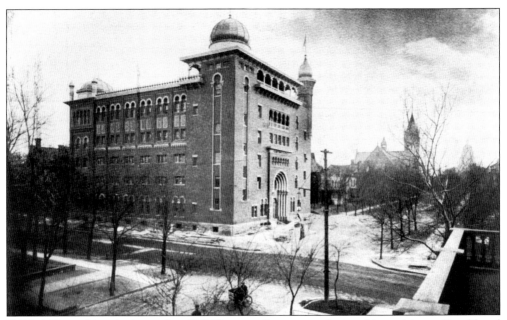

El Jebel Shrine Temple, located at 1770 Sherman Street, was designed by architects Harold and Viggio Baerrensen and was built in 1907. Truly one of Denver's time capsules, little has changed inside the building since the cornerstone was laid by the Ancient Order Nobles of the Mystic Shrine. The temple was designed in the Moorish style for the El Jebel Shriners. The Central Presbyterian Church and the State Capitol Building are on the right.

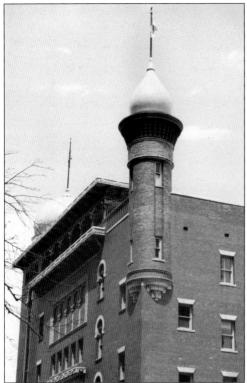

Decorated mainly with Persian and Egyptian motifs, the building once featured a Turkish smoking room, a Japanese room, and a number of other exotic interior spaces. The fourth and fifth floors are taken up by a spacious auditorium, with rooms off to the sides of each floor, including anterooms, lounges, and coat rooms. The auditorium can accommodate more than 400 people.

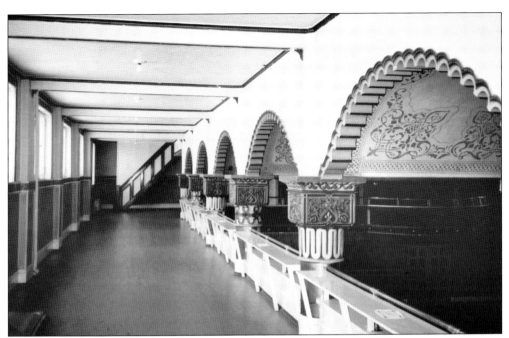

The ballroom on the two floors beneath the auditorium is a sight to behold, with its Byzantine decorations, stenciled crescent ceiling, and polished floor. A balcony surrounds the space, giving onlookers a lofty perch to watch the dance floor from any angle. It was the costliest Shriners' temple in the world when it was constructed at a cost of $180,000, a staggering sum during that era.

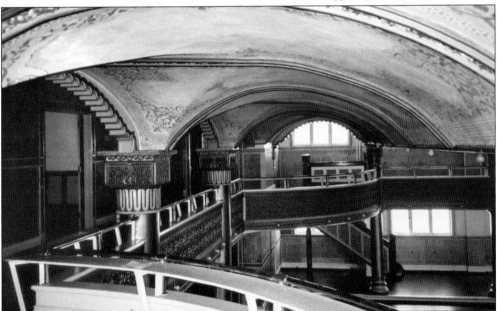

After a fire damaged the building in 1924, the Shriners moved to new quarters in northwest Denver. The Sherman Street building was used as the Rocky Mountain Consistory No. 2 until the 1990s, when the Eulipions, a cultural events group, moved in. The building was again sold in 2000. Now known as the 1770 Sherman Street Event Complex, it plays host to concerts, wedding receptions, parties, dances, and high school proms.

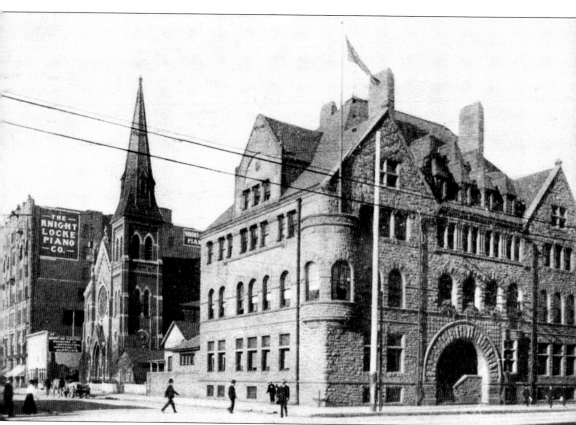

The Denver Club, located at 518 Seventeenth Street, was designed by architects Ernest Varian and Frederick Sterner and was built in 1889. In 1880, a group of Denver businessmen decided there was a need for a social organization for the business and professional men of the city. The first officers and directors included railroad man David Moffat, real estate and utility tycoon Walter S. Cheesman, Colorado governor and former mayor John Routt, and James B. Grant, the Colorado governor from 1883 to 1885. The handsome building was constructed in the Richardsonian style of granite and Colorado red sandstone. The interior was plush yet masculine: maroon velvet, wood paneling, leather chairs and sofas, and brass and crystal gaslights. Over the years, many of its members retired or died, and in 1952, it was sold to the Murchison brothers, John and Clint, Texas oil millionaires. Plans were made to demolish the old clubhouse for a new skyscraper, and in 1954, the club moved to the Murchisons' new high-rise. The Denver Club continues primarily as a squash club.

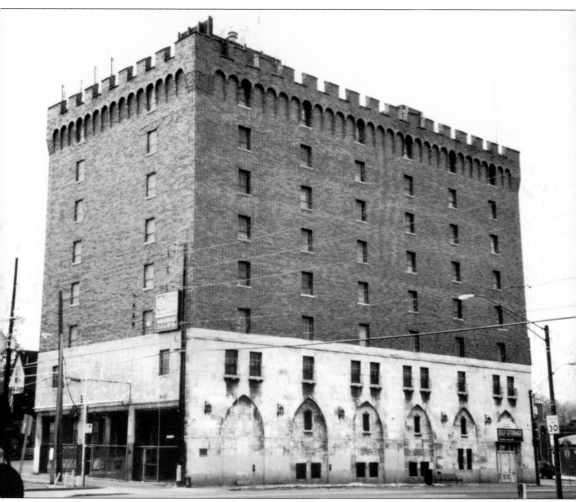

The Weicker Building, located at 2100 East Colfax Avenue, was designed by architects William Fisher and Arthur Fisher and was built in 1925. This fortress-like building is seen as an enigma to many of the thousands of drivers passing by the intersection of Colfax Avenue and Vine Street; a commanding presence looming above the surrounding shops and cafes like an eagle watching over its brood. It was built as a storage warehouse for the Weicker Moving and Storage Company, which already had large storage buildings elsewhere in Denver. In the mid-1920s, commercialism pushed up Colfax Avenue, once an elite section of Denver, and the wealthy homeowners moved out. At the same time the Weicker Building went up, the Capitol Hill State Bank was being erected two blocks east on York Street. The optimism of this rapid development was realized in a weekend festival held around the same time, when Colfax was filled with dancers, jugglers, and singers from York Street west to Vine Street. After many decades, Weicker vacated the building, but it continues to be used as a storage warehouse.

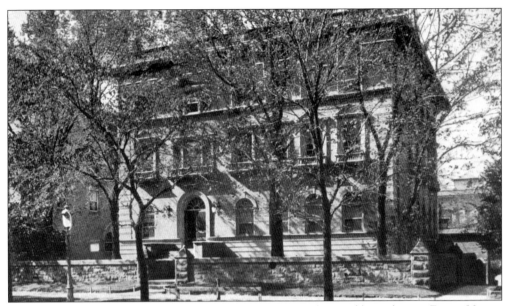

The University Club, located at 1673 Sherman Street, was designed by architects Ernest Varian and Frederick Sterner and was built in 1895. In 1880, Henry Rogers and his cronies formed a club where the educated of the city could meet, socialize, and advance themselves among others of their set. Modeled after similar clubs in New York, members of the University Club were Ivy League graduates, attorneys, and businessmen. All members were required to have a college degree, hence the name.

After meeting in a number of locations around the city, the Sherman Street building, in neoclassical style, was erected as the club's permanent home. The spacious rooms were male-oriented, with rich carpeting, dark paneled walls, and high windows—the archetypical men's club. In the early days, women were admitted when escorted by their husbands and only one day a week.

The University Club has seen a number of changes over the years, not the least of which has been remodeling and additions to the exterior that have radically altered the stately appearance of the original building. The interior, however, has benefited from these structural changes, adding room for dining and lounging.

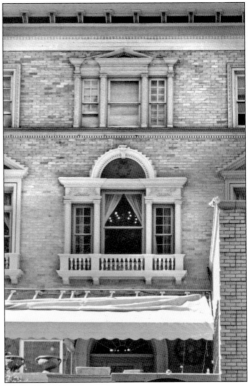

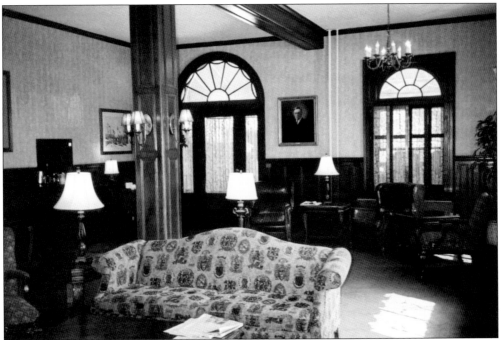

Club membership is limited to 500. Women are now admitted, and widows of members have been allowed to use the club's dining facilities for years. Members meet here to conduct business, meet with friends, read the latest news, discuss politics, and dine in one of eight banquet rooms.

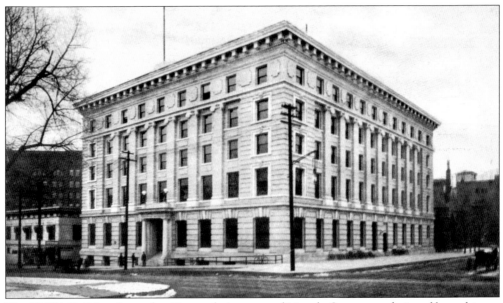

The YMCA Building, located at Sixteenth Avenue and Lincoln Street, was designed by architects Willis Marean and Albert J. Norton and was built in 1907. The Young Men's Christian Association traces its roots to London, where it was founded in the mid-1800s to combat unhealthy living conditions during the height of the industrial revolution. Denver's chapter had many homes, including the First National Bank building at Fifteenth and Blake Streets, and the Kittredge Building at Sixteenth Street and Glenarm Place.

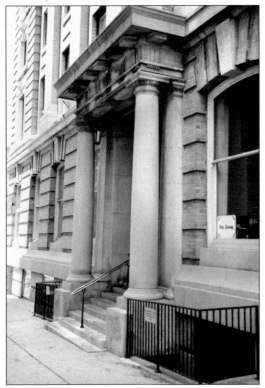

Generations of neighborhood children first learned to swim at the "Y" under the tutelage of Harry Ukelele, the swim instructor there for decades. The gym originally offered three separate systems of poles, rings, bars, and clubs. The expansive main lobby, with its Doric columns and mission-style furniture, contained the employment office, which found jobs for many of the young men coming into town looking for work.

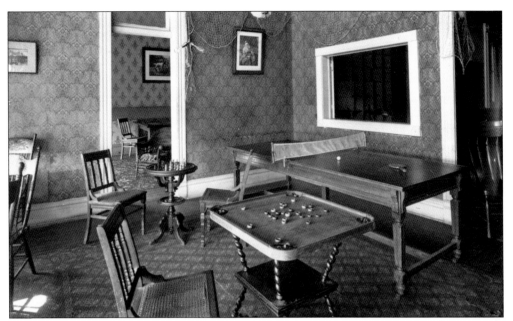

The second floor held many rooms that were devoted to games, educational and religious work, assemblies, and lectures. The Lincoln Street building has undergone a number of changes and improvements, including the construction of a six-story addition to the north in 1961. At its opening, the structure housed a new gym, a swimming pool, and handball and squash courts. (Courtesy of DPL.)

The YMCA has continued to thrive throughout generations of social change and upheaval. The Denver YMCA had a high school and junior college in the 1920s and provided temporary housing for many of the servicemen on leave from overseas during World War II. It continues to serve the central business district of Denver.

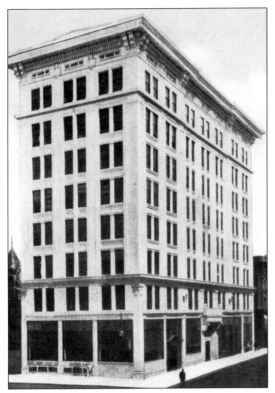

The Ideal Building, located at 821 Seventeenth Street, was designed by architects Montana Fallis and John Stein and was built in 1907. Charles Boettcher had already amassed a fortune in hardware, mining, cattle, and sugar when, around the beginning of the 20th century, he realized a need for local production of quality cement. Denver was booming, and there was a high demand for building materials. Boettcher, John Campion, and others founded the Portland Cement Company, which was later renamed the Ideal Cement Company.

As the company became one of the leading suppliers of cement in the West, Boettcher ordered the construction of a new building on Seventeenth Street. When completed, it was entirely fireproof, one of the first such structures in Denver. Designed in the Chicago Commercial style of marble, concrete, and tile, it was sold to the Denver National Bank and was completely overhauled in 1927, as shown here.

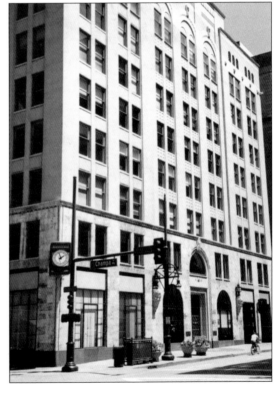

The remodeling project was overseen by architects William Fisher and Arthur Fisher. The building was gutted then greatly enlarged, with an addition built onto the north side facing Champa Street. The Denver National Bank occupied the first four floors. The elaborate use of French and Belgian marble enhanced the main interior spaces and lent an air of respectability.

The Denver National Bank merged with the U.S. National Bank in the 1950s, and the first four floors of the bank space were emptied. The Ideal Cement Company moved back in for a few years before finally going out of business. The Colorado Business Bank now occupies the former Ideal Building.

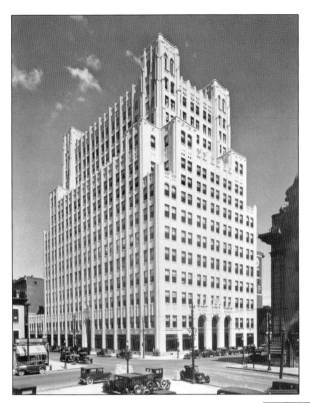

The Mountain States Telephone and Telegraph Building, located at 931 Fourteenth Street, was designed by architect William Bowman and was built in 1929. This monolithic building replaced earlier telephone facilities at 1421 Champa Street, which had become outdated due to the rapid growth of Denver during the 1920s. When the new building was finished, it was a marvel and the tallest building in the city. (Courtesy of the Colorado Historical Society.)

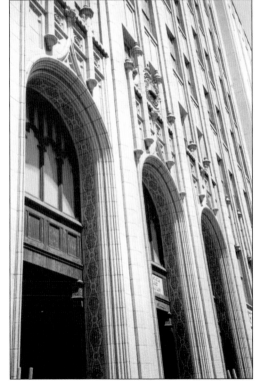

Although designed with Gothic Revival influences, the building exudes a certain modernistic character. This was certainly the case on the inside, where the latest communications technology was employed. It became the center of Denver's communication activities. There were originally two entrances, one on Curtis Street, now closed, and the other on Fourteenth Street.

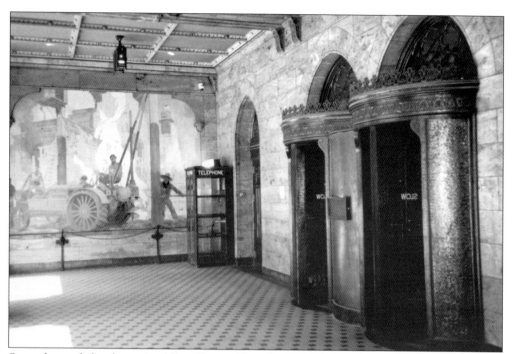

Several murals by the artist Allen Tupper True decorate the foyer and interior spaces of the building. True was also responsible for a number of other public decorations, including murals in the Colorado National Bank on Seventeenth Street, the Brown Palace Hotel, and the rotunda of the state capitol building.

The lobby was designed in the Beaux-Arts style. There is extensive use of marble and other stone throughout, along with brass and bronze for the stair railings and light fixtures. A large stained-glass skylight adds soft light to the space. The building has been in continuous use by the telephone company since it was built. (Courtesy of DPL.)

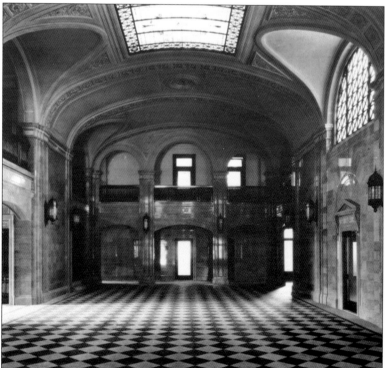

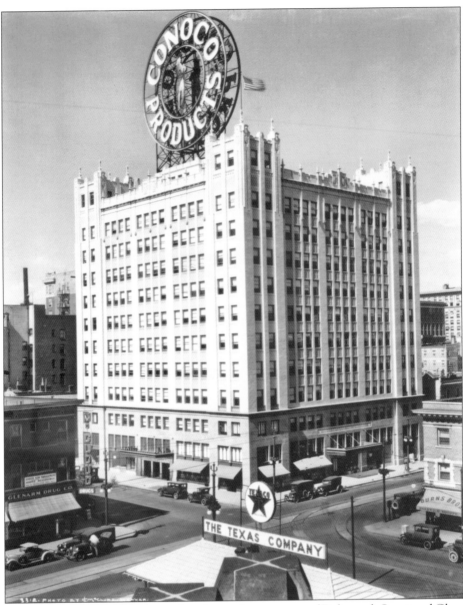

The Continental Oil Building, located on the southwest corner of Eighteenth Street and Glenarm Place, was designed by architect William Bowman and was built in 1927. The Continental Oil Company, better known as Conoco, came about in 1911 as a result of the break-up of the Standard Oil Company under the newly established anti-trust laws. At that time, Continental Oil was a small regional oil company operating in Colorado and Utah. The Continental Oil Building was constructed of steel and concrete, with a foundation 26 feet below street level and a full basement under the entire structure. The building covered an area 125 by 125 feet, with a court in the rear above the first floor measuring 34 by 70 feet. Ten stories tall, it was specially built to carry four more stories if the addition was ever called for, and in 1953, plans were proposed for those extra stories, to include a penthouse and the addition of an extra elevator, bringing the total to five. The exterior of the building was constructed of polished granite to the third floor and beige terra-cotta facing above. (Courtesy of DPL.)

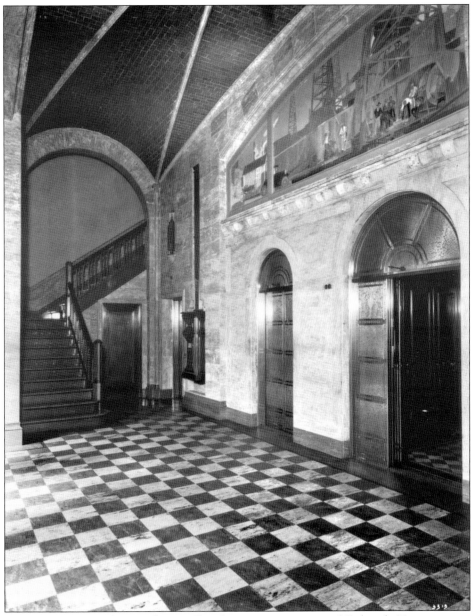

Four elevators ran to the top floors. The elevator entries were of Colorado Travertine, with painted murals over the elevator doors and at each end of the lobby. The corridors had marble wainscoting 4 feet high, tile floors, and a main entrance of highly polished marble, brass grilles, and bronze ornamentation. The main floor included an auditorium 47 feet long, complete with a stage, dressing rooms, and a projection booth. A massive Conoco sign was added to the roof in 1929 and was later changed from its round design to the more familiar triangle trademark. When completed, the Continental Oil Building became home to more than 30 tenants, including the Colorado Fuel and Iron Company, KFXF Radio Corporation, offices for Graham-Paige Motors, and offices for mining engineers, lawyers, and realtors. Continental Oil occupied the ninth and tenth floors. In the mid-1970s, the company moved to new quarters, and the old building was leveled to make way for an eight-story parking garage, which is still in use. (Courtesy of DPL.)

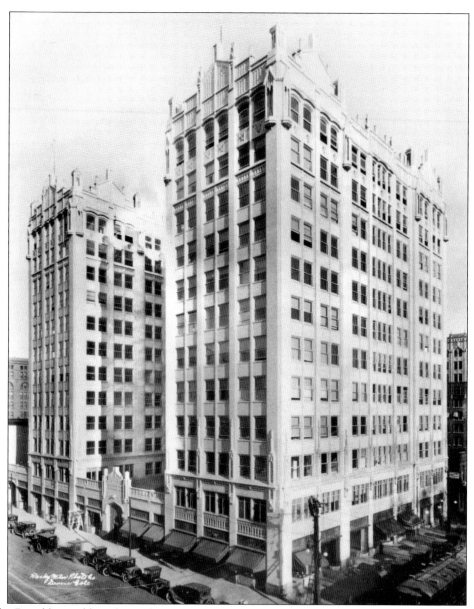

The Republic Building, located at 1600 Tremont Place, was designed by architect G. Meredith Musick and was built in 1925. The Republic Building had offices for more than 400 physicians and surgeons. It was here that many Denver children had their first encounter with the dentist's chair. The handsome U-shaped building, constructed for the exclusive use of members of the Medical and Dental Association and originally called the Medical Arts Building, was erected on eight lots and replaced a number of earlier houses and storefronts. Completely fireproof and constructed of riveted steel and poured concrete, it was Denver's largest commercial building when it was completed. It had a frontage of 200 feet along Tremont Place and 125 feet along Sixteenth Street. Designed with Gothic influences, the 160,000-square-foot building was constructed of beige brick and terra-cotta detailing with a granite base. The lobby, with a polished terrazzo floor and wrought-iron light fixtures, featured a brass cage elevator run by a uniformed operator. (Courtesy of DPL.)

Among the building's tenants were dentists and physicians, surgeons, attorneys, and architects. A drugstore was located on the first floor with a popular soda fountain toward the back that sold everything from ice-cream sodas to cherry and chocolate phosphates. The hallways had polished marble wainscoting. The bathrooms had marble partitions, floors, and wainscoting. (Courtesy of DPL.)

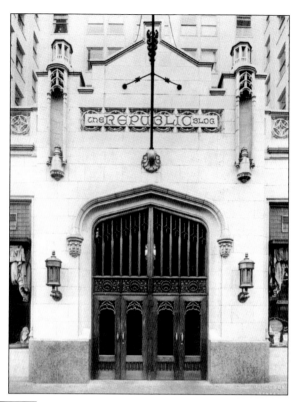

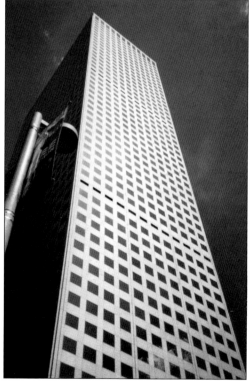

In 1978, the Republic Building was purchased by Philip Anschutz's Oxford/Ansco Development Company with plans to construct a new high-rise building on the site. Despite a campaign to save the structure by a group of preservationists, who managed to gather 8,000 signatures and turn them over to city council, demolition went ahead, and the 56-story Republic Plaza was completed in 1984 by the firm of Skidmore, Owings, and Merrill.

The Capitol Life Insurance Building, located at 1600 Sherman Street, was designed by architect Harry Manning and was built in 1924. Thomas Daly (1858–1921) made a fortune from the mines of Leadville, Colorado, and entered the insurance field in 1886. Before organizing his own company, he was with New York Life and the London Guarantee and Accident Company. He founded the Capitol Life Insurance Company in Denver in 1905 and established his offices in the Tabor Grand Opera House.

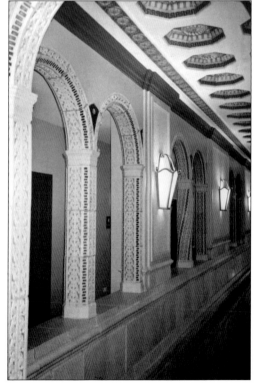

The original directors included Charles Boettcher, Frederick Bonfils, and John Campion, who married Daly's sister, Nelly. Thomas Daly died in 1921, and his son, Clarence, took over the helm. Ground was soon broken for his new Capitol Life Insurance Building at the northeast corner of Sixteenth Avenue and Sherman Street. Built in the neoclassical style, it is set on a base of granite.

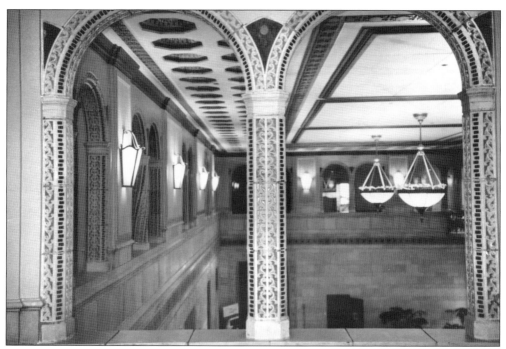

There is extensive use of Colorado Yule marble both on the face of the building and throughout the interior. This is enhanced with the use of terra-cotta detailing, including window frames and around the entrance doors. The entrance leads to a large, two-story hall surrounded with arched windows along the upper-floor galleries. The ceiling of this hall is highly detailed with octagonal insets.

In 1963, a high-rise addition was built to the east, but before long, the company experienced financial setbacks and eventually went out of business. The building is now home to the Colorado Trust, an organization established in 1985 to help promote and expand health care through grants and outreach programs.

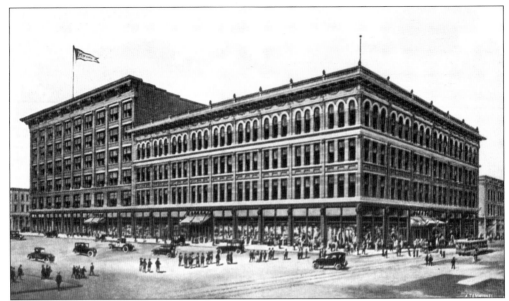

The Denver Dry Goods Company, located from Fifteenth to Sixteenth Streets on California Street, was designed by architect Frank E. Edbrooke and was built in 1888–1889. The company was established in 1879 as the McNamara Dry Goods Company. When Dennis Sheedy, a cattleman and president of the Globe Smelter, and banker Charles Kountze gained ownership of the store in the early 1890s, the name was changed. The store grew to be one of the largest shopping hubs in the West.

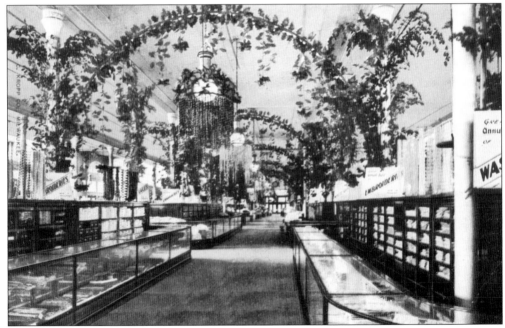

Kountze died in 1911, and Sheedy presided over the business until his death in 1923. His large funeral was held in the Cathedral of the Immaculate Conception. Sheedy, a lifelong Catholic, had contributed heavily to the church and had donated money for the construction of the cathedral, which is still located at Colfax Avenue and Logan Street.

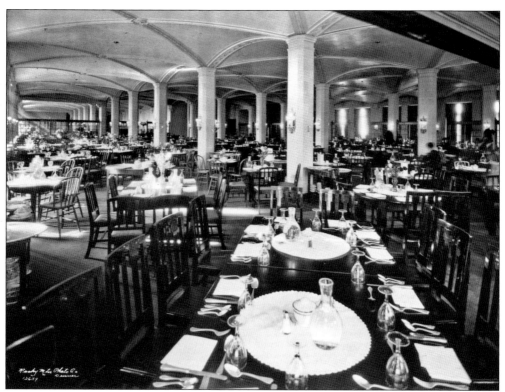

The store was a huge success. By 1910, it was the largest store in the Central West, measuring 400 feet long and containing 7 acres of floor space while employing 1,200 people. Decades later it became part of Associated Dry Goods. Under new leadership, the "Denver" expanded its operations to suburban malls in the 1960s and 1970s. The popular Tea Room is shown about 1920. (Courtesy of DPL.)

The building underwent expansions in 1898 and 1906, designed by Frank E. Edbrooke, and again in 1924. Sometime during its early years, the entire building was whitewashed and remained in that state until the 1990s, when its red brick was again exposed. The store closed in 1987. The building was renovated in the 1990s as a multiuse facility for office and retail spaces, along with apartments and condos on the upper floors.

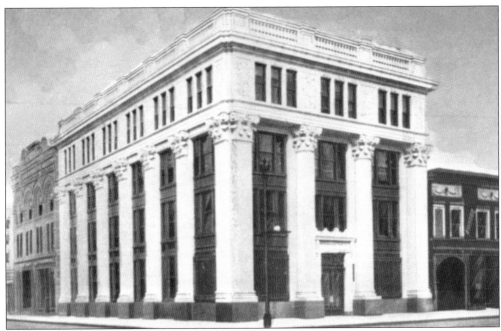

The International Trust Company, located at 625 Seventeenth Street, was designed by architects William Fisher and Arthur Fisher and was built in 1912. Constructed with a gleaming white-marble exterior over a fireproof steel-and-concrete shell, the International Trust Company exuded solidity to its patrons. The doors to the basement vault weighed 35 tons. The company was started in Denver in 1885.

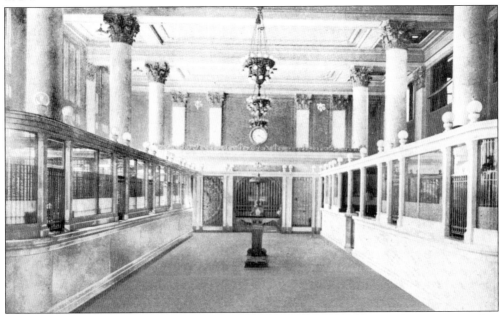

The lobby (shown here) featured every modern convenience. The building underwent a complete modernization in 1958 as part of the 28-story First National Bank of Denver tower, located in a new plaza designed by Paul Friedberg of New York, rendering it virtually unrecognizable. The former International Trust Company Building was razed in 1974.

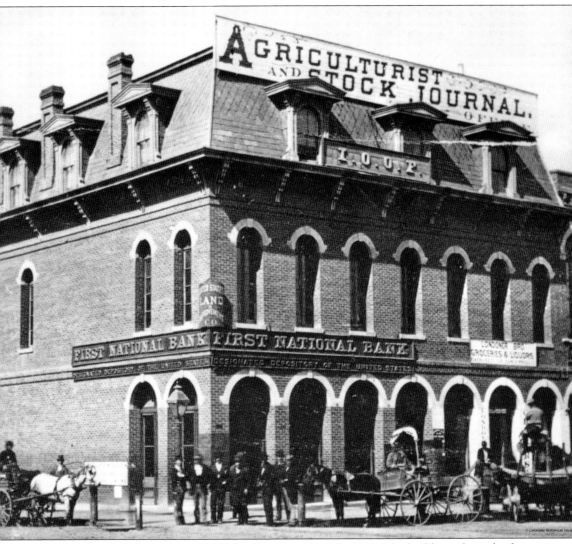

Constitution Hall, located at 1507 Blake Street, was built in 1865. The building where the first state constitution was drafted, Constitution Hall later became the first permanent home of the First National Bank of Denver. Constructed originally as a two-story, flat-roofed structure, a third story was added in the early 1870s, complete with mansard roof, in the French Second Empire style. It was here, in 1875, that the U.S. government was petitioned to admit Colorado to the Union, an act that was granted the following year. For years, the cavernous brick structure was home to the Stores Equipment Company, a supplier for restaurants and hotels. On April 24, 1977, Denver's third-oldest building was seriously damaged by fire, and arson was suspected. The hall sat gutted for more than two and a half years. After futile attempts to save the building by Historic Denver Inc. and the Colorado Historical Society, the remaining walls were demolished. (Courtesy of the Colorado Historical Society.)

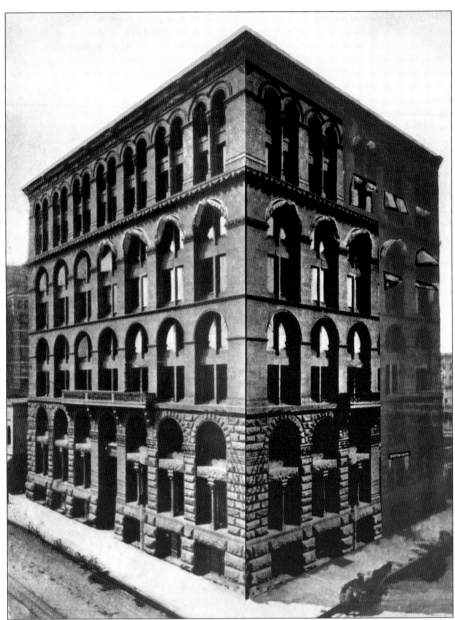

The Boston Building, located at 828 Seventeenth Street, was designed by architects Andrews, Jaques, and Rantoul and was built in 1890. This nine-story, red sandstone building, erected in the middle of downtown's financial district, was designed with Romanesque elements to convey a solid presence. The Boston Building replaced Wolfe Hall, the prestigious girls' school headed by Anna Wolcott before she moved to her own building at Fourteenth Avenue and Marion Street. For years, the Boston Building was home to investment offices, including those of Claude K. Boettcher, whose father, Charles, built the Ideal Building directly across Seventeenth Street. The Boston Building was known as the first modern office building to be erected in Denver. It was also home to the Big Horn Land and Cattle Company, Thomas Walsh's architectural offices, and the headquarters for the Struby-Estabrook Mercantile Company. The building was completely renovated in the late 1990s and is now known as the Boston Lofts.

Three

THEATERS AND RESTAURANTS

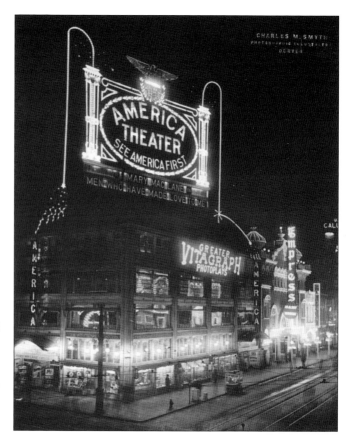

In the 1910s and 1920s, Curtis Street was known as the brightest street in America due to the thousands of electric lights decorating the theaters lining the way, from Fifteenth to Twentieth Streets. At one time, there were no less than 10 such movie palaces on this street alone. Shown here are the America and Empress Theaters. (Courtesy of DPL.)

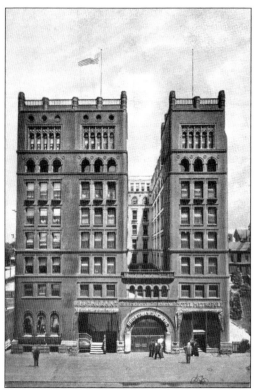

The Broadway Theater, located at 1756 Broadway, was designed by architect Frank E. Edbrooke and was built in 1890. One of Denver's most respected theaters, the Broadway was part of the Metropole Hotel (pictured here), which was constructed on the block originally owned by Henry C. Brown, builder of the adjacent Brown Palace Hotel. On this block also was the home of Silver King Horace Tabor and his wife, Augusta. The house was demolished in 1903.

The Broadway Theater's brilliant opening night saw many of the city's most prominent citizens occupying the hundreds of seats and 25 boxes. The main curtain was painted with an East Indian scene, and the overall decoration of the interior space was so exotic that it raised more than a few eyebrows among the well-traveled patrons. (Courtesy of the Colorado Historical Society.)

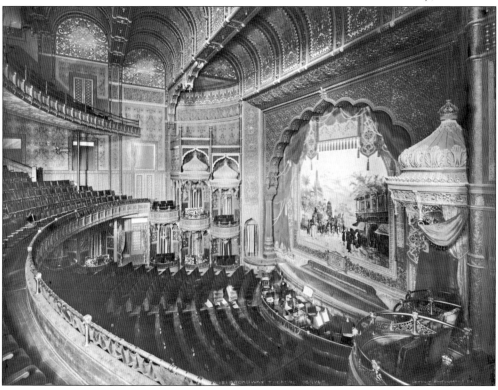

The stage was 40 feet deep and 75 feet high. Behind the stage were three lofts, a scenery dock, and the stars' dressing rooms. The theater played host to everything from grand opera to school pageants. The Metropole Hotel was annexed by the new Cosmopolitan when that hotel opened in 1926 just to the north. The theater was demolished in 1955. (Courtesy of DPL.)

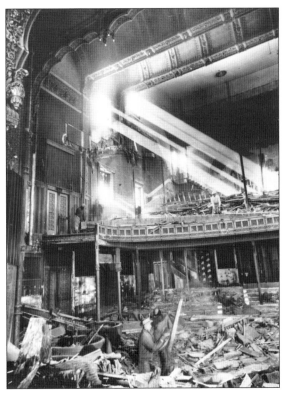

When the Broadway Theater was torn down, its former lobby was taken over by Trader Vic's Restaurant (later called Don the Beachcomber). After the hotel was demolished, some of the remaining walls were used by Wells Fargo Bank (foreground).

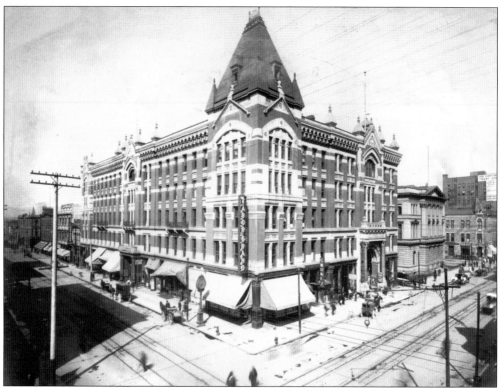

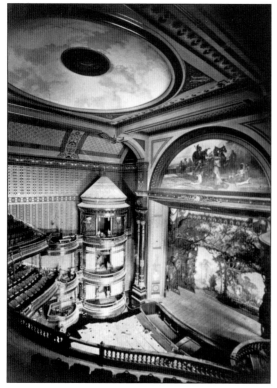

The Tabor Grand Opera House, located on the southwest corner of Sixteenth and Curtis Streets, was designed by architects Willoughby and Frank E. Edbrooke and was built in 1880–1881. Horace A. W. Tabor made his fortune in the silver mines of Leadville, and having already built a great opera house there, moved his family to Denver and immediately began making plans to build an even bigger opera house. The finest woods were used for the building, including Japanese cherry and Honduras mahogany.

Three entrances opened into a rotunda, roofed with stained glass. Next to this area was the lobby, decorated with two immense mirrors and a ceiling painted with frescoes. The hallways were covered in rich Wilton carpeting of crimson with a green border. Plush mohair seats and curved balconies faced the large stage, which measured 72 feet wide by 50 feet deep. (Courtesy of DPL.)

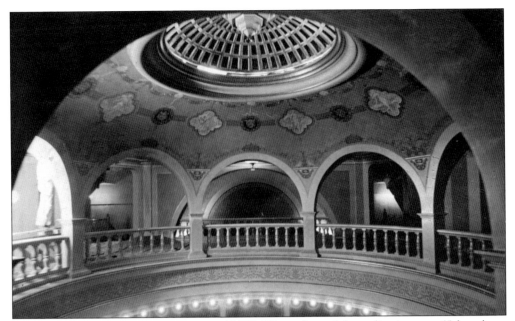

The opera house had a seating capacity of 1,500. The ceiling of the auditorium was 65 feet above the floor. In the center was a circular dome measuring 30 feet across. The seats were covered with crimson plush. The building was remodeled to accommodate motion pictures in 1921, and the name was changed to the Colorado Theater. Donald O'Connor and Judy Garland both performed there early in their careers. (Courtesy of the Colorado Historical Society.)

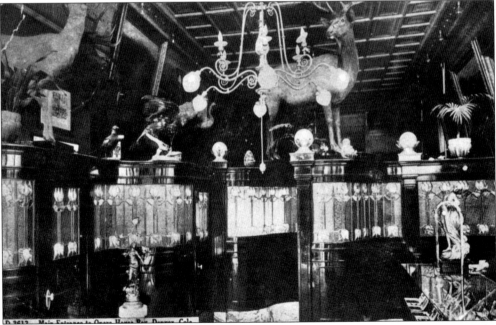

Goldsmith's Buffet is pictured during the theater's height. The theater held its own during the heyday of the movie palaces but, like many, started to feel the pinch by the mid-1940s. It was sold for $1 million in 1949, but it could not compete with newer theaters and was torn down in 1964. The site is now occupied by the Denver branch of the Federal Reserve Bank of Kansas City.

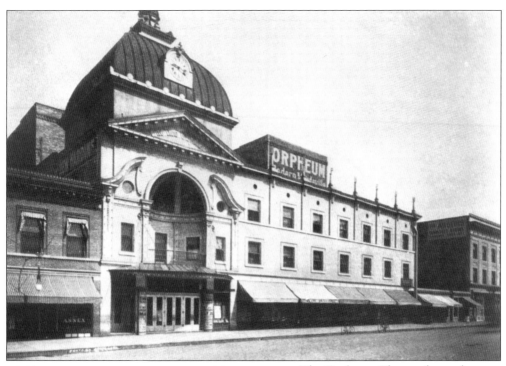

The Orpheum Theater, located at 1537 Welton Street, was designed by architects Willis Marean and Albert J. Norton and was built in 1903. It was constructed at a cost of $200,000, with a seating capacity of 2,000, with 12 boxes. The Orpheum stretched 80 feet along Welton Street and extended back 125 feet to the alley. The large circular dome was built over the entrance and was used as a gallery.

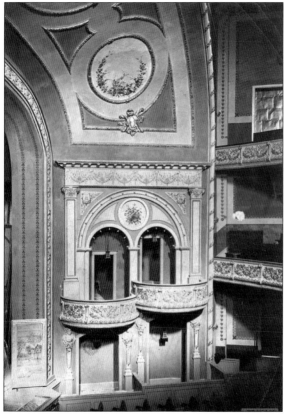

The theater had its own orchestra with a continually changing roster of musicians and conductors. The Orpheum was also a key theater in the western half of the Keith-Orpheum circuit, one of the most successful vaudeville operations in the country. The circuit featured in-person performances by such big names as Sophie Tucker, George Jessel, the Marx Brothers, Bert Williams, and Will Rogers. (Courtesy of the Colorado Historical Society.)

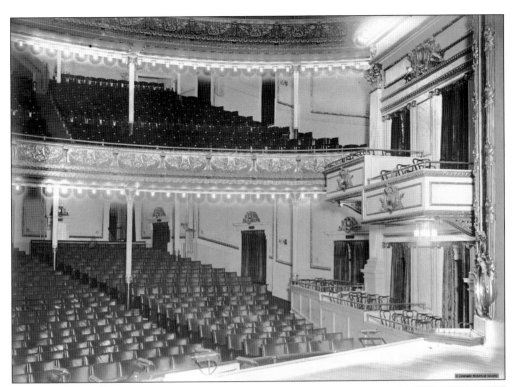

By 1930, the Orpheum was starting to show its age. Management decided to level the building and erect a new one in its place that was bigger and better than the first. This was done at a cost of more than $1 million, a staggering amount of money in the early days of the Depression. The new house opened in 1932, boasting a larger stage and screen. (Courtesy of the Colorado Historical Society.)

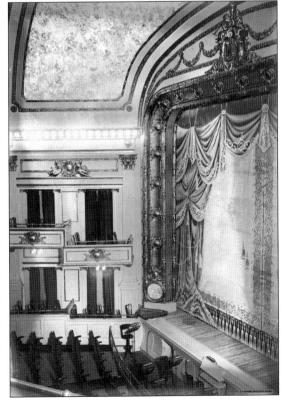

The Orpheum hit the same slump as many other theaters in the mid-1950s due to the advent of television and the flight of many to the suburbs. Within a few years, the theater became the Radio-Keith-Orpheum (RKO) and, still later, the RKO International 70. The Orpheum closed about 1965, and the building was demolished in 1967. It has been a parking lot ever since. (Courtesy of the Colorado Historical Society.)

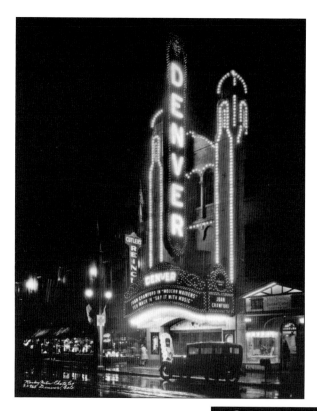

The Denver Theater, located at 516 Sixteenth Street, was designed by architect William Bowman and was built in 1927 in conjunction with the renowned team of Barney and A. J. Balaban and Sam Katz for the Publix Theater Corporation. The Denver Theater opened as the city's premiere movie theater in November of that year. The cost of construction was reportedly $2 million. The lobby measured 125 feet long and 35 feet wide, and was two stories high. (Courtesy of DPL.)

Four crystal chandeliers hung from above, each more than 7 feet in length. Polished marble walls were adorned with French beveled mirrors, and the lobby was painted in shades of rose, ivory, and gold. Off the main lobby was a music room where patrons were entertained by a concert pianist during intermission. Two opposite staircases ascended to the mezzanine promenade, which circled the lobby. (Courtesy of DPL.)

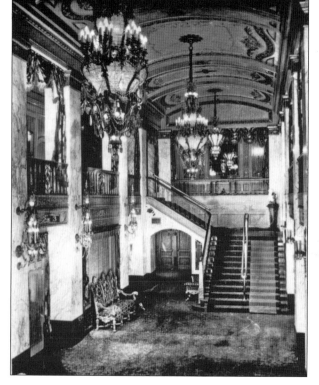

On both sides of the entrance were large mirrors, each 24 feet high by 18 feet wide. The theater was one of the first to offer "refrigerated air" in the summer, making it an attractive destination in the days before home air-conditioning. It was a weekend destination for generations of Denver children. (Courtesy of the Colorado Historical Society.)

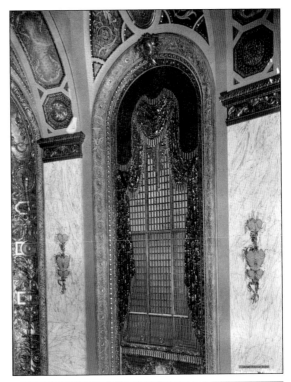

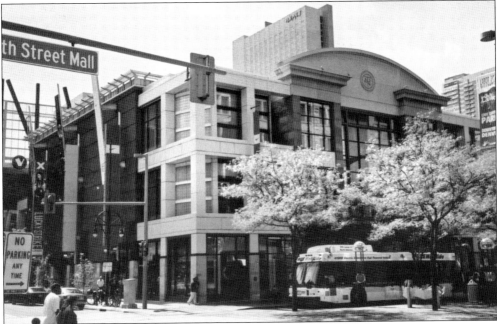

Live entertainment was also featured at the theater, including Duke Ellington and Gypsy Rose Lee, the striptease queen. The Denver Theater was remodeled in 1952, and many of the interior embellishments were either removed or covered over. The theater continued successfully into the 1970s but was torn down in the early 1980s. The site is now part of the Denver Pavilions shopping complex, shown here.

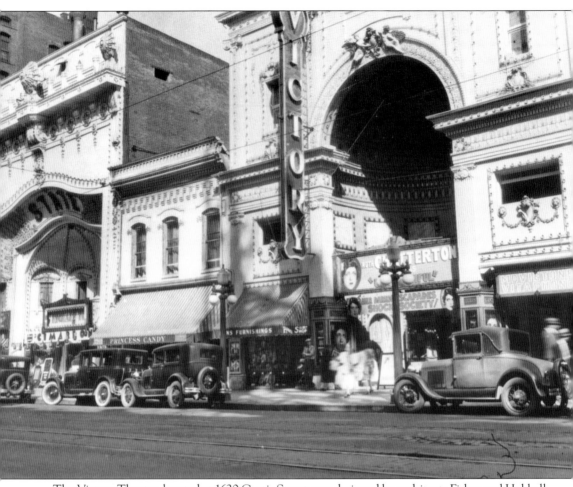

The Victory Theater, located at 1620 Curtis Street, was designed by architects Fisher and Hubbell and was built in 1909. The Victory Theater opened as the Princess Theater, a vaudeville and novelty house, with 1,140 seats. It presented movies in the days of the early silents. Its first film showing was *Queen Elizabeth*, starring Sarah Bernhardt. Before the advent of sound, theaters in downtown Denver offered a wide array of entertainment choices. It was common practice to offer stage shows immediately preceding the movie. These ran the gamut from dancers, acrobats, jugglers, vaudeville routines, and solo musicians, to magicians, organ recitals, recitations and lectures, and orchestral revues. Each of the larger theaters had its own music director, and there was a tight-knit group of organists and other musicians who would float between these theaters almost exclusively. Concessionaires sold popcorn, caramel corn, taffy, cotton candy, and soft drinks, with prices generally running from 5¢ to 20¢. Admission for a matinee ranged from 5¢ to 75¢. The theater was renamed the Victory in 1924. (Courtesy of DPL.)

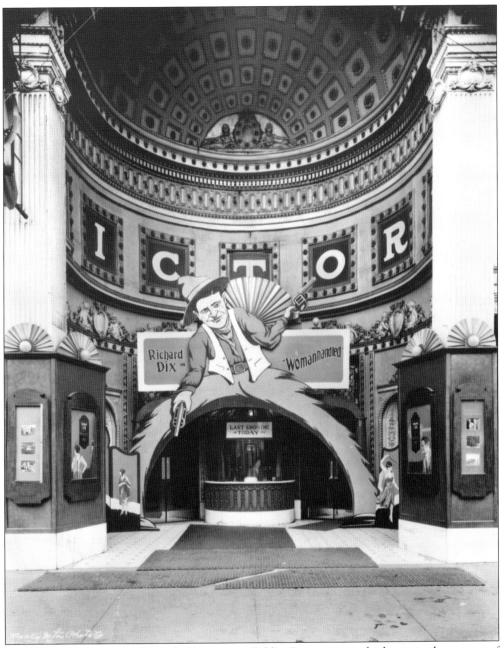

In 1927, the Victory was sold to the Paramount-Publix Corporation, which was in the process of constructing the new Denver Theater at Glenarm Place and Sixteenth Street, and when that structure was completed, the Victory was sold to a group of investors, among them J. B. Melton, who eventually closed it. Melton then opened a New Victory in the old Empress Theater just across the street. The old Victory was reduced to a mountain of plaster and lumber in 1940. The New Victory did not fare well. Revenues started to sag, and attendance dropped as patrons were being lured to newer, more modern theaters either downtown or in the suburbs. The New Victory Theater was closed in 1958 after a few years of trying to revive burlesque by featuring "girlie" shows. The building was torn down in 1969, a victim of urban renewal. (Courtesy of DPL.)

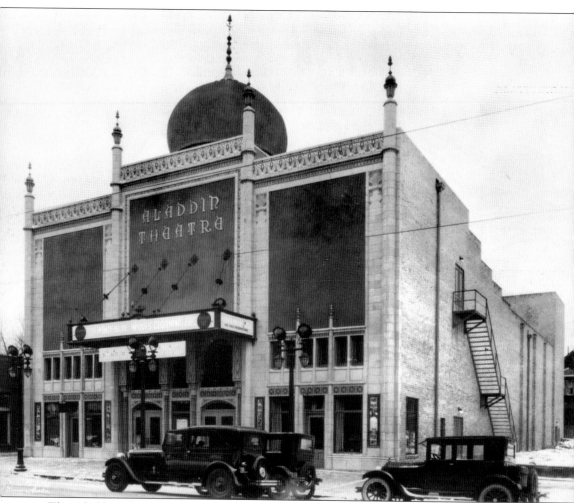

The Aladdin Theater, located at 2000 East Colfax Avenue, was designed by the architecture firm of Ireland and Pau. One of the city's most-celebrated neighborhood theaters, the Aladdin opened to great fanfare in 1926. The public was held in awe at the sight of luxurious carpets in jade green and an expansive auditorium ceiling painted sky blue with hundreds of tiny, twinkling lights. Visitors found Arabian murals and even a bubbling fountain. Congratulatory telegrams streamed in from Hollywood studio heads. The lobby was lined with stands of flowers sent by well-wishers. The Aladdin opened in the days of the silent movies but was quickly converted to the latest technology: sound. In 1927, the Aladdin had the first showing of the Vitaphone film *Don Juan*, starring John Barrymore, grandfather of actress Drew Barrymore. Later that same year, the public was treated to a run of *The Jazz Singer*, with Al Jolson. (Courtesy of DPL.)

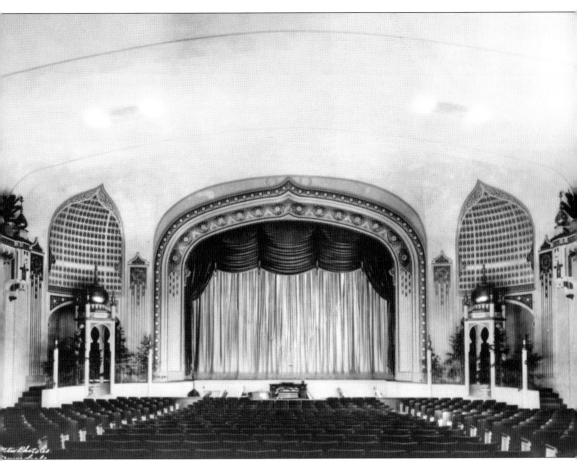

In the late 1970s, revenues started to slip at the theater, in spite of showing such Hollywood hits as *The Omen* and *The Duchess and the Dirtwater Fox*. Part of the reason was the growing popularity of the smaller multiplex theaters and the decline of the Aladdin's neighborhood in general. In the early 1980s, Aladdin's management decided to drop film fare entirely and replace it with live theater. The idea of live theater never caught on at the Aladdin. Reasons varied, but by that time, the surrounding area had gained a wide reputation as a rough neighborhood. By the early 1980s, the Aladdin was up for sale, and the theater was torn down in 1984 to make way for a Walgreen's drugstore. The glory days of the big screen theaters in Denver were over. (Courtesy of DPL.)

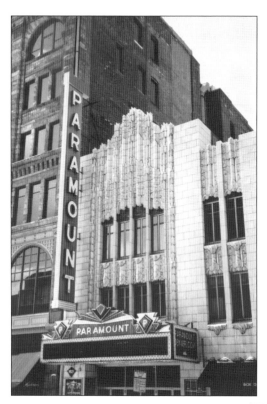

The Paramount Theater, located at 1621 Glenarm Place, was designed by architect Temple Buell and was built in 1930. Downtown Denver took on the appearance of Hollywood when the million-dollar Paramount Theater—the first in the city to be constructed solely for the showing of talking pictures—held its gala opening to a crowd of nearly 5,000 moviegoers and well-wishers. Thousands more showed up to get a glimpse of the event.

Local dignitaries, city officials, and scores of prominent citizens attended the showing of the comedy *Let's Go Native*, starring Jack Oakie and Jeanette MacDonald. When the doors were flung open, Denver got a glimpse of an art deco paradise. Visitors were greeted by a spacious lobby with a long, sweeping stairway leading to the balcony. At one time, a lobby entrance was located in the Kittredge Building fronting Sixteenth Street.

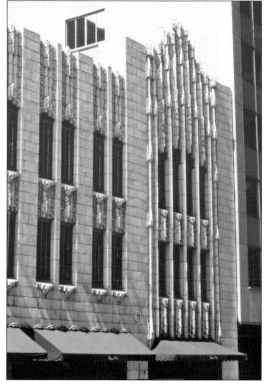

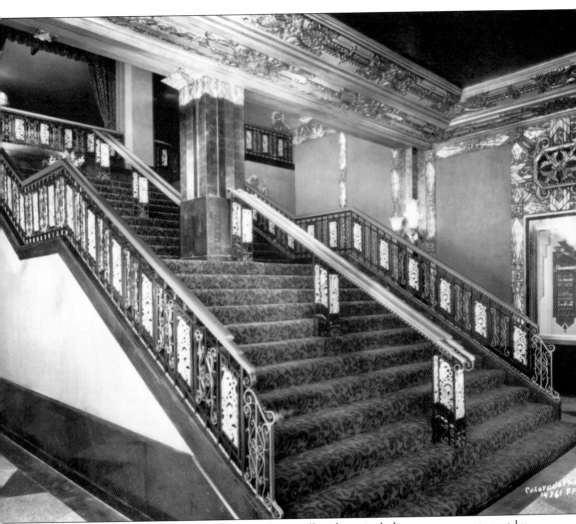

The lobby was decked with banks of flowers from well-wishers, including arrangements sent by notable Hollywood celebrities, along with a huge floral display spelling "Paramount" in 1-foot-high letters. Outside, huge searchlights crisscrossed the skies as darkness fell. Preshow musical numbers were played by two female musicians sitting at the twin consoles of the gigantic Wurlitzer theater organ. These were the days of ushers in starched uniforms, piercing the semidarkness with their flashlights as they guided theatergoers to their seats. Scores of people manned the concessionaire booths, the ticket booth, and the projectionist booth. The opening of the Paramount Theater ushered in Denver's modern-day moviegoing and was a mainstay for entertainment during the years of the Great Depression. Most recently, the Paramount has played host to live music performances; Dick Gibson's jazz concert series was a popular event for years. (Courtesy of DPL.)

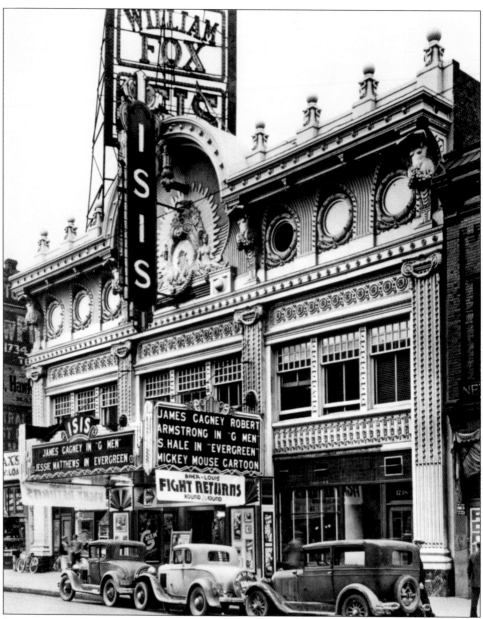

The Isis Theater, located at 1722 Curtis Street, was designed by architect Robert Roeschlaub and was built in 1912. Theaters such as the Isis were the hub of Denver's entertainment in the early days before the advent of radio and television, and were used not only for motion pictures, but also for vaudeville, lectures, children's events, traveling theater groups, and social and political meetings. Elaborately designed both inside and out, the Isis had 1,800 seats and a stage large enough for live entertainment. Admission was 10¢ to 25¢; popcorn or candy was another nickel. The Isis boasted the largest Wurlitzer theater organ in the country, a console organ with four manuals built at a cost of $50,000. Organ concerts were a big draw, and the Isis had a unique system whereby a remote-controlled (by electric cable) player piano, off to the side of the stage, played either solo or in conjunction with the organ. The Isis Theater site has been used for public parking since the building was torn down in 1955. (Courtesy of DPL.)

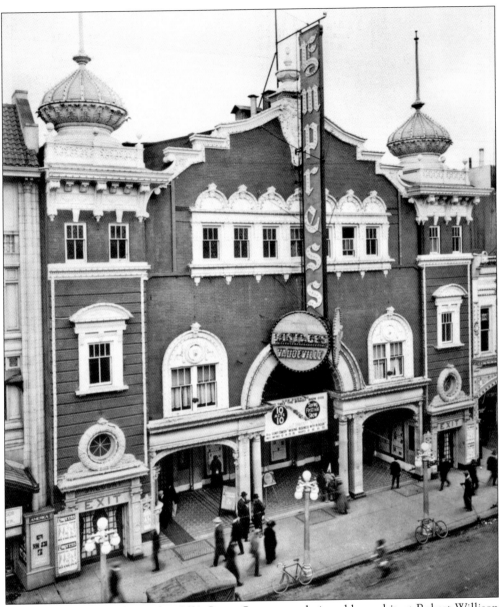

The Empress Theater, located at 1621 Curtis Street, was designed by architect Robert Willison and was built in 1907. Originally opened as the Majestic Theater, the Empress was also known over the years as the Pantages, the Center, and the New Victory. It was built to seat 1,400 patrons. The exotic facade had an arcade-style entrance and two onion domes separated by an ornamental parapet. The interior featured a smoking room in the basement, a main-floor coatroom, four three-tier crystal chandeliers, and an Egyptian-style stage curtain. The Empress featured stage shows and vaudeville in its earliest days, and made the switch to movies in the 1920s. Just before the outbreak of World War II, the Empress closed, and the Victory Theater, originally located across the street at 1620 Curtis Street, moved into the old Empress space. The New Victory struggled through the 1950s with adult-oriented movies and finally closed. The Empress/New Victory and the America Theater next door are gone, and the property has been taken up by the Rock Bottom Brewery and the multistory Independence Plaza. (Courtesy of DPL.)

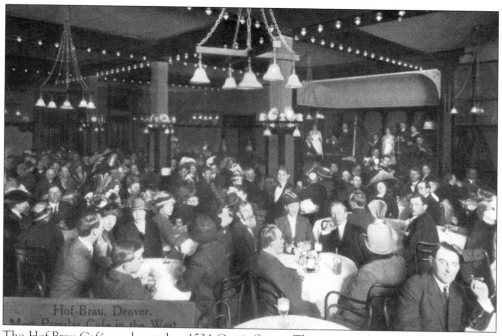

The Hof-Brau Café was located at 1534 Curtis Street. There were a large number of popular restaurants and cafes in downtown Denver from the 1900s through the 1930s. Among them were the Manhattan, Pell's Oyster House, the Watrous Café, the Blue Parrot, Holland's the Yellow Lantern, the Edelweiss, and the Navarre Café. (Courtesy of a private collection.)

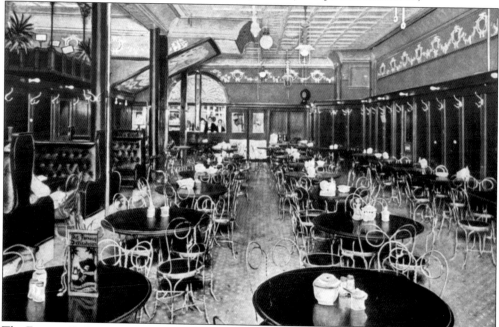

The Famous Café was situated at 1000 Fifteenth Street. Many of downtown Denver's restaurants and cafés were long and narrow, owing to the shallow width of the buildings available for such purposes. This in no way negated the popularity of these venues. The Famous Café doubled as a saloon in the era of beer and cigars.

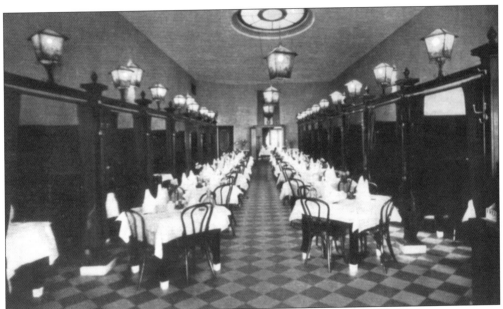

The Parisienne Rotisserie Inn served patrons at 1721 California Street. In the early days of the 20th century, this unique Italian and French restaurant was the only true French restaurant in the city and was the predecessor of the immensely popular Boggio's Parisienne Restaurant, which was located farther east, near Broadway and Tremont Place.

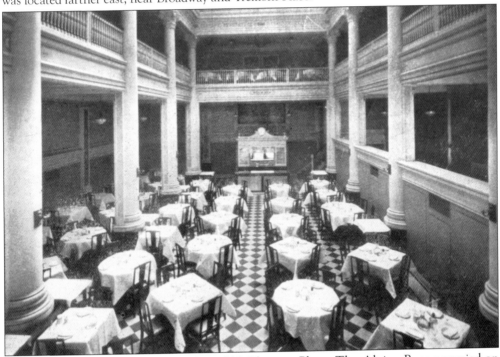

The Café Alpine Rose was located at 1648 Glenarm Place. The Alpine Rose occupied an unusually elegant space in a narrow building near the east end of downtown; however, the seating arrangement was typical for the time. It is almost reminiscent of the layout used on some of the ocean liners of the early 20th century.

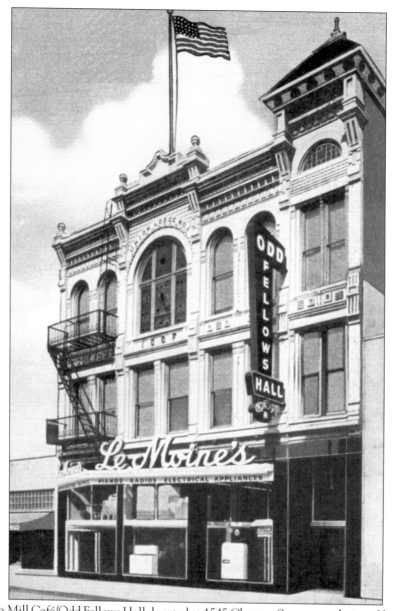

The Dutch Mill Café/Odd Fellows Hall, located at 1545 Champa Street, was designed by architect Emmett Anthony and was built in 1889. One of downtown Denver's most popular spots, the Dutch Mill Café originally opened as a cabaret located on the main floor of the Odd Fellows Hall in a building designed in the Romanesque Revival style. The two upper floors were taken up by the Odd Fellows, one of the largest and oldest fraternal orders in the United States. The café opened in 1910. The waitresses were almost exclusively blond and were dressed in Dutch costumes with wide-brim hats and wooden shoes. The café was decorated to resemble a small Dutch village. There was a circular balcony built three quarters around the interior and a lit revolving windmill. Chorus girls danced down a ramp from the balcony singing popular songs of the day while an orchestra played from a balustrade on the main floor. The Dutch Mill closed in 1935. The Odd Fellows sold the property in 1983. An extensive renovation followed. It is a designated Denver landmark.

Four

CHURCHES

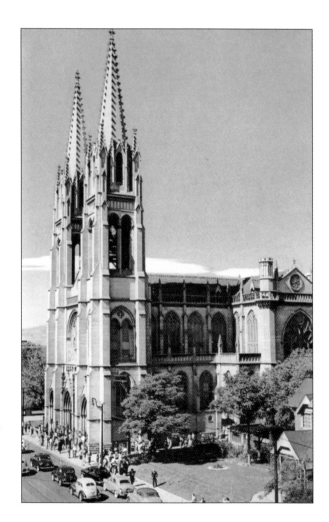

Religion played a major role in the city's formative years. Downtown and Capitol Hill were dotted with churches of every size and denomination. Pictured here is the jewel in Denver's Catholic crown: the Cathedral of the Immaculate Conception. It was dedicated in 1912 and is still standing at Colfax Avenue and Logan Street.

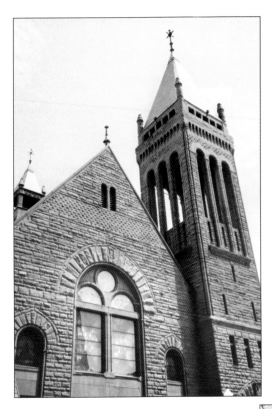

The Central Presbyterian Church, located at 1660 Sherman Street, was designed by architect Frank E. Edbrooke and was built in 1889–1892. Denver's first Presbyterian services were held in a schoolroom in the summer of 1860. In 1865, the congregation opened its first permanent church building on Fifteenth Street between Lawrence and Arapahoe Streets. A bigger church was later built at Eighteenth and Champa Streets. The cornerstone for the Sherman Street church was laid on July 7, 1891.

The building was designed in a simple, yet awe-inspiring manner in the Romanesque style. Constructed of red sandstone, the church gives the appearance of having been on the site for centuries. Its tower rises 185 feet above the sidewalk. The auditorium is 110 by 142 feet with open galleries above. Pews fill the center of this space, and boxes were built under the galleries in a descending fashion.

The organ loft fills the entire space on the Seventeenth Avenue side. The organ, built by Farrand and Votey of Detroit, was one of the finest in the country when it was installed. It contains three manuals of 65 notes with 2,495 pipes. In an age when gas lighting was common, the church elected to use both gas and electricity, so lighting fixtures were built with both.

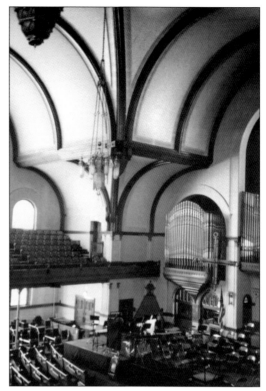

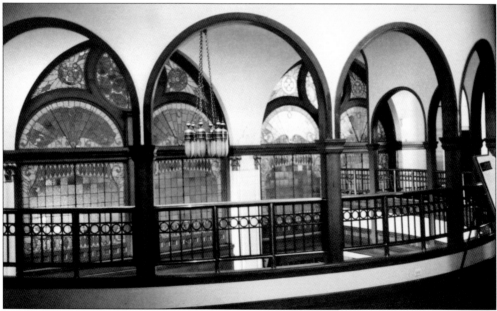

From the beginning, missionary work has been an integral part of the church. Missionaries were sent to such far-flung places as China, Alaska, and Siam. The church has responded to worldwide disasters, reached out to the elderly, and helped the homeless. It was among the founders of the Presbyterian Hospital. The Central Presbyterian Church continues its important work, both locally and abroad, to this day.

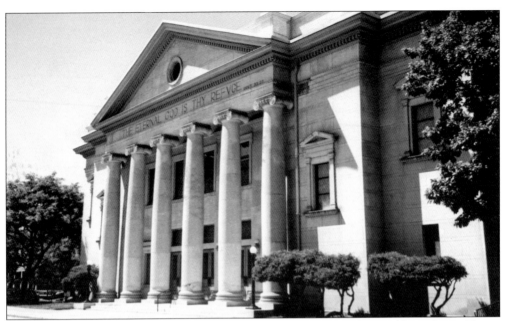

First Church of Christ, Scientist, located at 1401 Logan Street, was designed by architect Ernest Varian and Frederick Sterner and was built in 1901–1907. In 1879, Mary Baker Eddy founded the Church of Christ, Scientist, and authored the fundamental text that was the basis of church beliefs, *Science and Health with Key to the Scriptures*. As a chronically ill young woman, she developed an interest in healing through faith and focused her attentions on the development of Christian Science.

Eddy devoted the rest of her life to the establishment of churches across the country. In 1908, she founded the *Christian Science Monitor*, a journal that many non-practitioners are familiar with. It is still published weekly in print and daily on the Internet. Eddy died in 1910 at the age of 89. Since her death, more than 2,000 branch churches have been established throughout the United States and overseas.

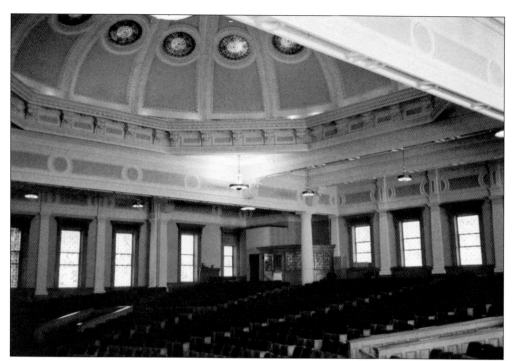

In 1891, a Christian Science church was erected at 1751 Logan Street. It served parishioners until a larger church was built just south, at 1401 Logan Street. Construction began in 1901, but the church was not dedicated until October 13, 1907. Designed in the Greek Revival style and built of white lava stone, the 15,625-square-foot building is capped with a copper dome and is faced with six massive pillars.

The foyer is 50 feet wide and 115 feet long. This foyer leads to the auditorium, which seats 1,000. The centerpiece of the auditorium is the 3,336-pipe organ, built by Casavantes Freres of Quebec, Canada. The stained-glass windows throughout were manufactured by the Kokomo Opalescent Glass Company of Indiana. Prominent Christian Scientists have included Lady Nancy Astor, Joan Crawford, and Ginger Rogers.

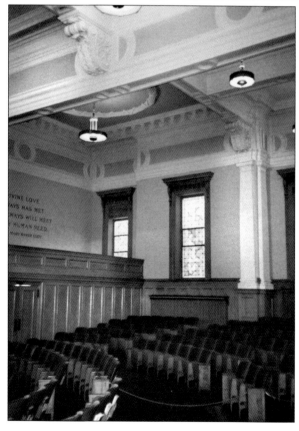

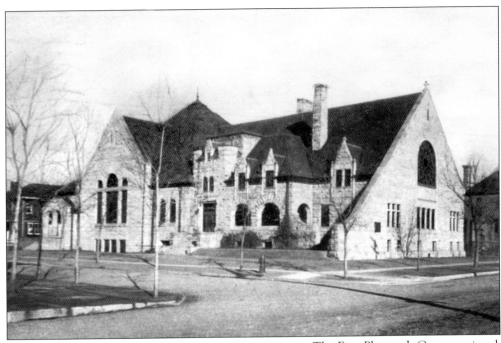

The First Plymouth Congregational Church, located at 1400 Lafayette Street, was designed by architects Ernest Varian and Frederick J. Sterner and was built between 1893 and 1899. The National Council of Congregational Churches traces its roots to 1871. The Plymouth Congregational Church offered services here before it merged with First Congregational, which was then located on Glenarm Place.

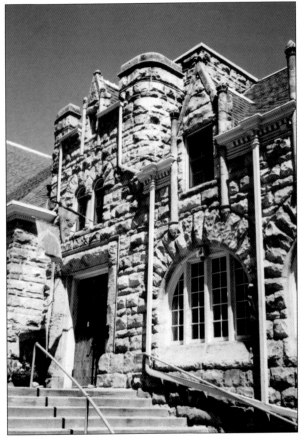

When the building was completed, it boasted a large auditorium with a pulpit, choir stalls, and a three-manual pipe organ. In the 1950s, choirmaster J. Allen Grubb was also choir director for the Easter sunrise services held yearly at the Red Rocks Amphitheater. The Congregationalists used this building until the late 1950s, when they moved to new quarters in south Denver at Hampden Avenue and Colorado Boulevard.

In 1873, the Unity Church was located downtown at Seventeenth and California Streets. Church members moved to a larger building at Nineteenth Avenue and Broadway in 1887 and moved again to 1400 Lafayette Street in 1958. It has been home to the First Unitarian Church ever since.

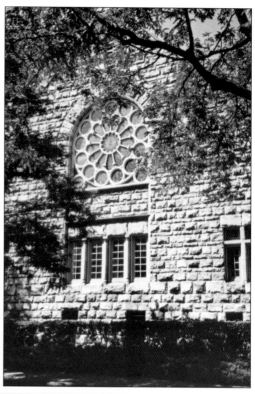

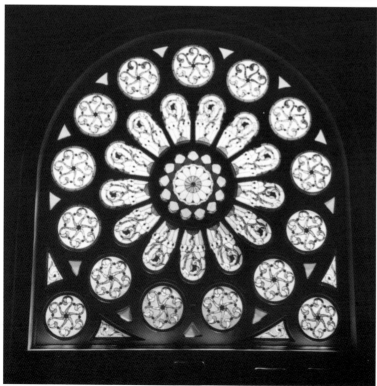

In 1985, a disastrous fire burned much of the roof and the interior, and destroyed a number of the original stained-glass windows. Church members decided to stay and rebuild. While the interior has been greatly altered, the architectural integrity of the building remains intact. The rose window, in the second floor chapel, survived the fire.

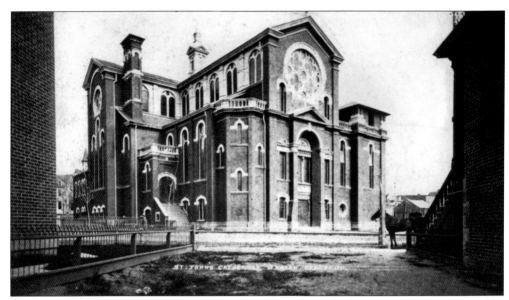

St. John's Episcopal Cathedral, located at Twentieth Street and Glenarm Place, was designed by architect Gordon Lloyd and was built in 1881. Known as the "Church in the Wilderness," St. John's Episcopal Cathedral was established in the early 1860s by Rev. John Kehler and was first located at Fourteenth and Arapahoe Streets. Under Kehler's leadership, the congregation grew, and in 1881, a new church was built at Twentieth Avenue and Glenarm Place. (Courtesy of DPL.)

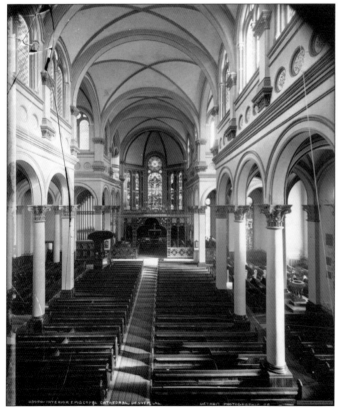

Designed in the Romanesque style, it was one of the most beautiful and commanding cathedrals in the city. It was constructed of pressed brick with the exterior walls faced with stone. It measured 140 by 100 feet at the transept. The nave had 104 pews and even more in the transepts. There were 22 stained-glass windows filtering the sunlight. (Courtesy of the Colorado Historical Society.)

On May 14, 1903, a major fire swept through the cathedral, leaving only the walls standing, destroying everything inside, including the organ, as well as stained-glass windows and marble statuary. It was decided to build a new cathedral at another location, farther south, at Fourteenth Avenue and Clarkson Street (pictured here).

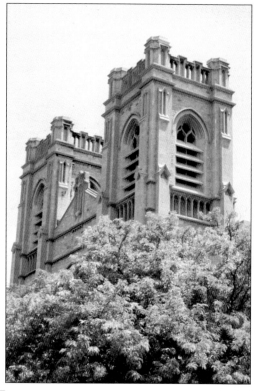

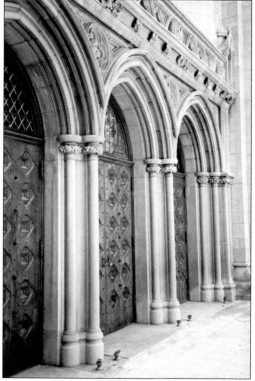

The first services were held at the new Gothic-style cathedral in November 1911, making St. John's one of the oldest congregations in the city. Although it has weathered tough times over the years, it remains a solid stronghold in the Anglican church system. The Reverend Canon Robert O'Neill is bishop of Colorado.

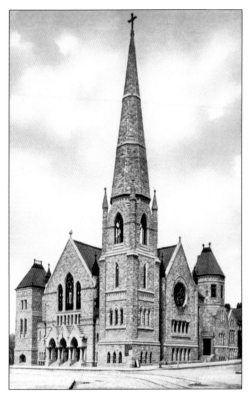

Trinity United Methodist Church, located at Eighteenth Avenue and Broadway, was designed by Robert Roeschlaub and was built in 1887–1888. The Methodists of Denver had congregated in various locations downtown before building a permanent church at the corner of Fourteenth and Lawrence Streets. After two decades there, it became evident that larger quarters were needed, and property was purchased to the east, on Broadway.

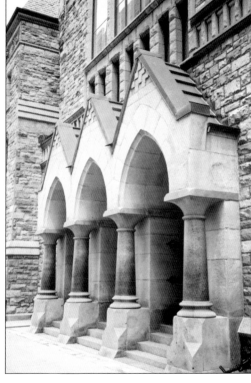

Rev. Henry Buchtel (1847–1924) led the drive to raise funds for a new church building, and the first services were held there in 1888. Buchtel later became chancellor of the University of Denver and a Colorado governor. The church is built of rusticated stone and is decorated with many large stained-glass windows.

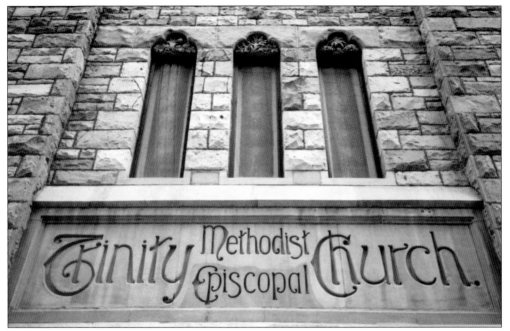

Trinity United Methodist Church served the downtown and north Capitol Hill areas through the first half of the 20th century before falling on hard times. By the 1960s, the neighborhood had changed drastically and took on a transient character. It became a struggle for church leaders to retain permanent members.

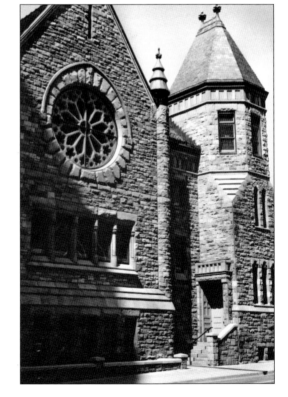

The area began to turn around in the 1990s, and the church now maintains a respectable membership. It is one of the oldest churches in Denver. At one time, its neighbors included Brinton Terrace to the east and the Cosmopolitan Hotel to the south. Church offices were once located in an addition to the north, which has been demolished.

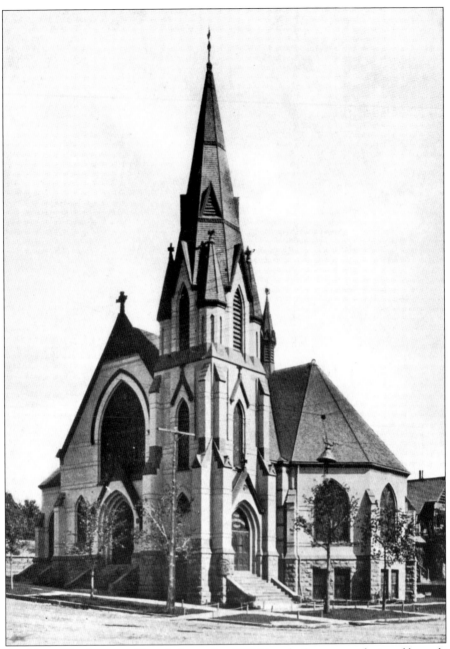

The First United Presbyterian Church, located at 1380 Lincoln Street, was designed by architects William Fisher and Ernest Varian and was built in 1883. Constructed in the Gothic style to accommodate up to 800 parishioners, the main auditorium had a large vestibule in front with three entrances to the street. The interior was an octagonal shape with large transepts at the sides and aisles radiating from the pulpit. The vaulted ceiling was an intricate design of plaster moulding and wooden beams. The church served the residents of Capitol Hill for more than 80 years. In the mid-1960s, the building was aging, and the congregation moved its quarters west to Jefferson County. The Lincoln Street building was then demolished. The site, adjacent to the state capitol and the capitol annex buildings, now provides parking for government employees.

Five

SCHOOLS

By the last quarter of the 19th century, Denver was known nationwide for its excellence in education. Some of the finest schools in the state were located within its city limits. Shown is the dormitory for the former Cathedral High School, one of Denver's preeminent Catholic schools, at Nineteenth Avenue and Grant Street. Built in 1921, it is now Seton House, one of Mother Teresa's missions.

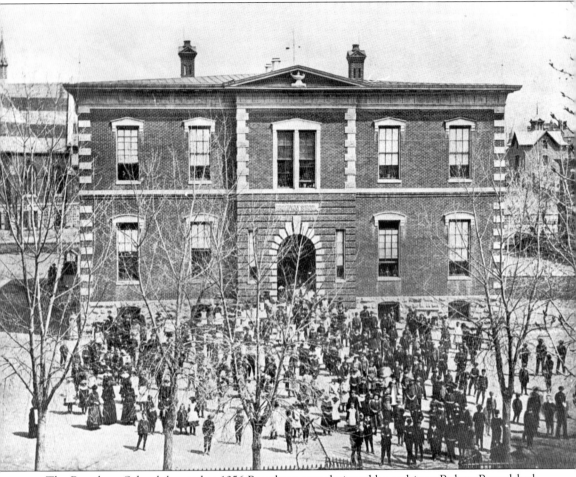

The Broadway School, located at 1356 Broadway, was designed by architect Robert Roeschlaub and was built in 1875. In 1874, Henry C. Brown, who owned large parcels of land throughout Denver, sold some acreage to the Denver school board for the construction of the Broadway School, later to be known as the Broadway Latin School. It was completed the following year. Initially an elementary school, it later became a junior high school and ultimately a Latin school, meaning it catered to college-bound students. Some who attended the eight-room school in the early years described their experience as "very hard work," where they were taught Latin, Algebra, and American history. The Broadway School owed its allegiance to East High School because it was the home of East's freshman class when that school was located at Nineteenth and Stout Streets. When the new East High School was constructed at Colfax Avenue and Detroit Street in 1924–1925, it abandoned the Broadway School altogether, as it now provided room for all four classes and no longer needed a separate building for just its freshmen. The old Broadway School soon closed. (Courtesy of the Colorado Historical Society.)

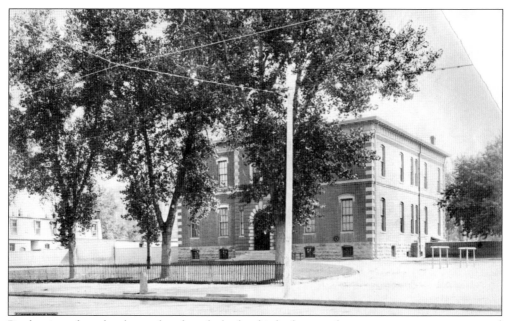

By the time the school was abandoned, the land it had sat on for so many years was prime real estate, and it was eyed by developers. Most of the block had filled with commercial development, including a drugstore, a Western Union, a Franklin motor car dealership, the C. C. Hall Cadillac dealership at Fourteenth Street and Broadway, and the Paramount Apartments at 1375 Lincoln Street. (Courtesy of the Colorado Historical Society.)

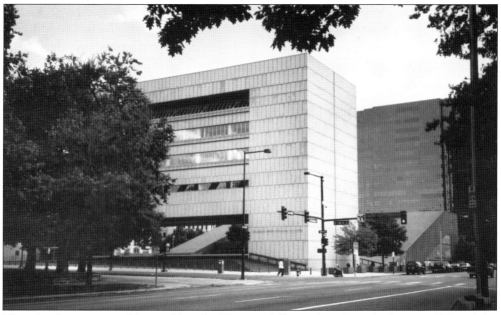

The school property itself was sold to the Western Gillispie Auto Laundry Inc. in 1928, and the old school was demolished. In the late 1970s, this entire block was leveled to make way for the Colorado State Judicial Building and the Colorado Heritage Center/Colorado State Museum. This block, again, is slated for demolition. The Colorado Heritage Center will occupy a new building at the corner of Twelfth Avenue and Broadway.

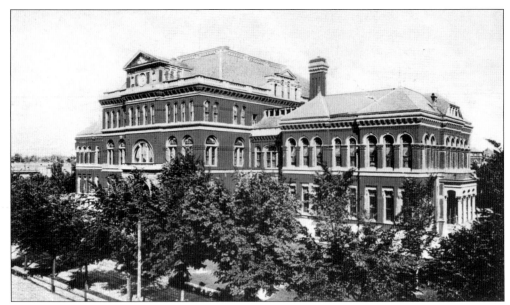

The East Denver High School, located at Nineteenth and California Streets, was designed by architect Robert Roeschlaub and was built in 1889. One of the finest school buildings in Denver was constructed on the block bounded by Nineteenth, Twentieth, Stout, and California Streets, with massive dimensions of 224 by 114 feet. When finished, its students numbered 500. The East Denver High School originally held classes out of the old Arapahoe School before getting its own building.

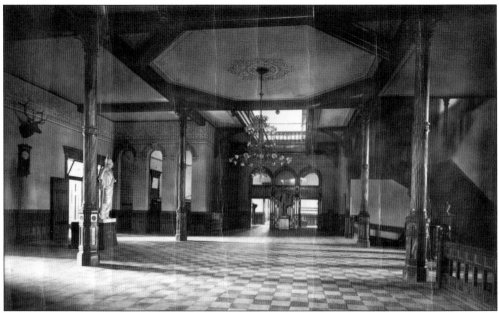

The building cost around $300,000, with a roof of slate tiles and three porches of white sandstone. Stone columns supported the roof and cornices. Students expected a well-rounded education with emphasis on the classics, geography, mathematics, and peripheral classes that included drawing, music, and calisthenics. All were geared toward college admission. (Courtesy of the Colorado Historical Society.)

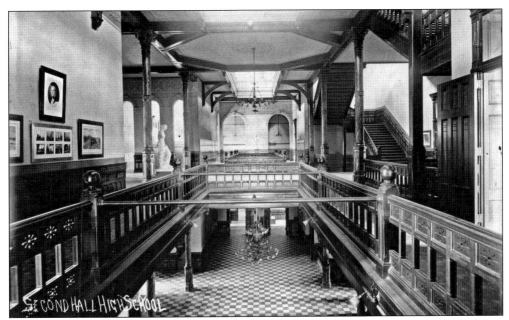

The East Denver High School was *the* school. A promotional advertisement read, "Graduates readily gain admission to any college in the country, and the record made by many of them is a source of pride." However, by 1911, parents petitioned the city to move the school away from downtown, and a decade later, construction began on one of the city's most beautiful buildings. (Courtesy of the Colorado Historical Society.)

The new East High School, designed by George Williamson, was completed in 1925 near Colfax Avenue and Detroit Street. It is an unexpected sight to travelers unfamiliar with the area. A few large statues were brought from the old building and placed in the main hall of the new one. The New Customs House, completed in 1931, occupies the old downtown property.

The Wolcott School, located at 1410 Marion Street, was built in 1898. Anna Wolcott (1868–1928), mistress of her namesake school, was the sister of two prominent and powerful men, both important in the early years of Denver's development. Henry R. Wolcott was treasurer of the Colorado Smelting and Mining Company. He was instrumental in the construction of the Equitable and Boston Buildings in downtown Denver. Edward O. Wolcott was an influential politician and attorney.

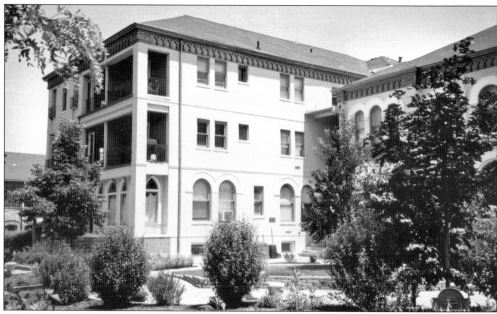

In 1892 Anna Wolcott was named principal of Wolfe Hall, which was first located downtown and then at Fourteenth Avenue and Clarkson Street. In 1898, she founded the Wolcott School for Girls. It quickly became the preferred school for the daughters of Denver's elite. Alumni included Helen Brown, daughter of Margaret "Molly" Brown of Titanic fame, former first lady Mamie Eisenhower, and Clara Cody, granddaughter of William "Buffalo Bill" Cody.

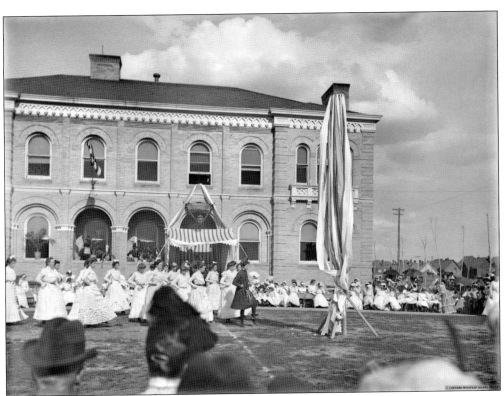

The school, two buildings connected by a passageway across an alley, had every amenity, including a gymnasium, an auditorium, a swimming pool, large classrooms, and dormitories. The music room had a small pipe organ. The school's programs, quaint by today's standards, included annual maypole dances (pictured here) and a Maids of Mist celebration. (Courtesy of the Colorado Historical Society.)

Anna Wolcott became the first female regent at the University of Colorado. She married Joel F. Vaile in 1912. The school closed in 1924, and the building was converted to apartments. The swimming pool was boarded over and is now used for storage. A former bowling alley is now a corridor from one area of the basement to another. The building stands as a testament to Capitol Hill's decorous days.

2231 WYMAN SCHOOL.

The Wyman School, located at 1600 Williams Street, was designed by architect Robert Roeschlaub and was built in 1890–1891. The Wyman School was once the most progressive, well-equipped elementary school in Denver. Its cavernous interior included carved wood, massive stairwells, high ceilings, and spacious classrooms. Two gyms, one for boys and the other for girls, were located at opposite ends of the basement. Wyman's alumni included silent-screen star Douglas Fairbanks; Paul Whiteman, a popular bandleader known as the "King of Jazz;" and actress Barbara Rush.

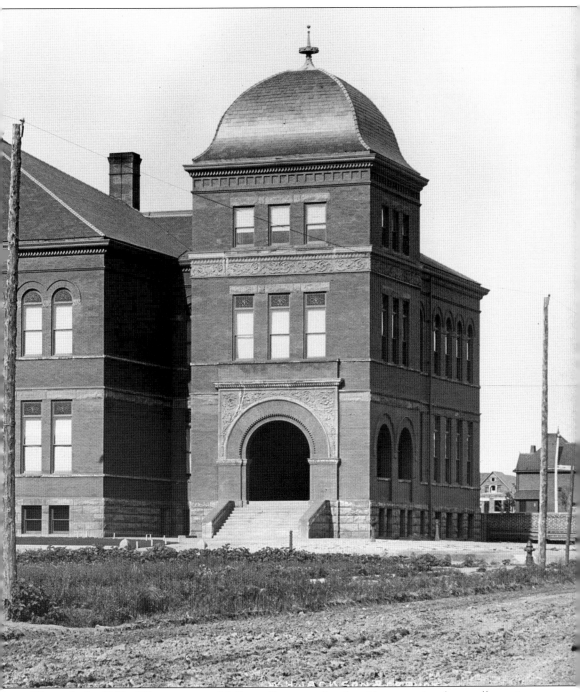

Through the 1950s, Wyman enjoyed full enrollment and a citywide reputation for excellence in education. By 1970, however, the school was considered aged and outdated. The school board voted to demolish it in 1973 and replace it with a new building, complete with moveable walls and learning pods. The Wyman School was closed permanently in 2008. (Courtesy of the Colorado Historical Society.)

Wolfe Hall, located at 840 East Fourteenth Avenue, was built in 1888. This institution was originally established downtown in the late 1860s, at Seventeenth and Champa Streets, as a private girls' school run by Episcopalians. Lessons were geared toward all the proprieties of the Victorian age, much the same as a finishing school. Anna Wolcott became headmistress, and the school moved uptown to Capitol Hill (shown here) in 1889.

Wolcott left in the late 1890s to establish her own school at Fourteenth Avenue and Marion Street. Wolfe Hall closed about a decade later. Denver Public Schools bought the property, and the building was demolished. In its place rose Morey Junior High School (pictured), which, as Morey Middle School, continues to serve a large portion of Capitol Hill.

Six

RESIDENCES

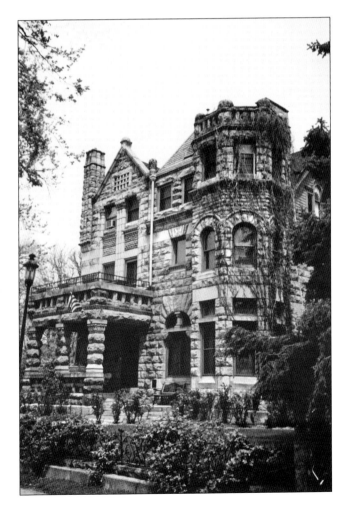

Private homes were once found throughout the downtown Denver area, but commercial buildings slowly pushed them out. Many residents moved to adjacent Capitol Hill. Mansions shared the spotlight with apartments and small houses. Castle Marne, at Sixteenth Avenue and Race Street, (pictured here) was one of a handful in the Wyman Historic District of Capitol Hill that was converted for use as a bed-and-breakfast.

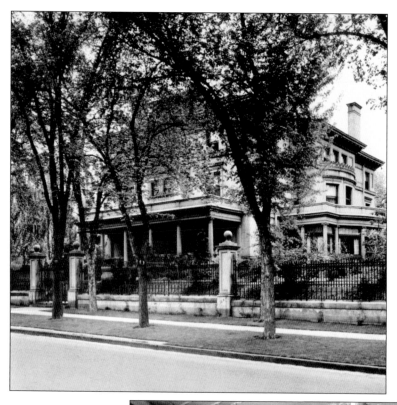

The John Campion House, located at 800 Logan Street, was designed by architects Aaron Gove and Thomas Walsh and was built in 1896. In the last part of the 19th century, John Francis Campion, Leadville mine owner and operator, struck it rich with his Little Jonny gold mine. He soon moved his family to Denver's Capitol Hill, by then the new enclave of the city's wealthy citizens, and there he built his dream home. (Courtesy of John C. Mulvihill.)

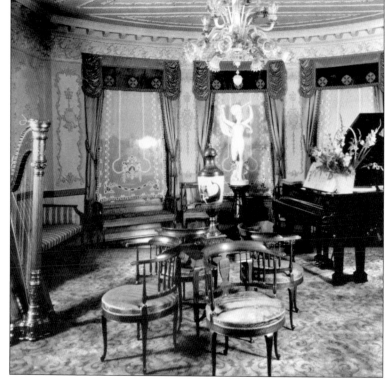

Constructed of gray sandstone in the Italian Renaissance style, the mansion stood four stories high with a full basement. The interior spaces were finished with a variety of hardwoods. Found on the main floor was the drawing room, the music room, the dining room, a large central hall, and the kitchen. The second and third floors contained bedrooms and servants' quarters, with a ballroom on the top floor. (Courtesy of John C. Mulvihill.)

Most of the city's society crowd lived in Capitol Hill. Among Campion's neighbors were Colorado pioneer and industrialist Charles Boettcher; Simon Guggenheim of the Guggenheim mining family; James B. Grant, president of the Omaha-Grant Smelter and one-time Colorado governor; and druggist-turned-entrepreneur Walter Scott Cheesman. (Courtesy of John C. Mulvihill.)

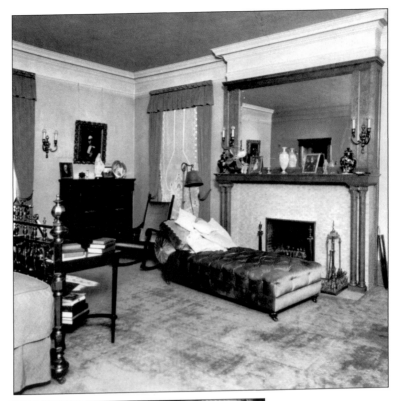

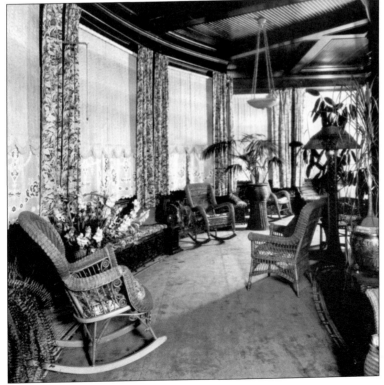

John Campion died in 1916. The house was acquired by the Boettcher Foundation in 1940 and was given as a gift to the Denver chapter of the American Red Cross. The mansion continued to house offices of the Red Cross until the early 1960s, when they were relocated to a new building in south Denver. The mansion was torn down and replaced with a high-rise apartment building. (Courtesy of John C. Mulvihill.)

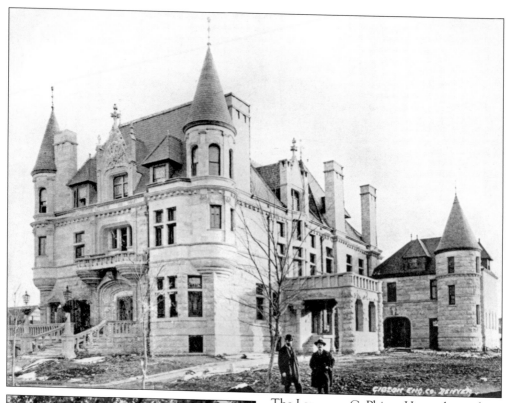

The Lawrence C. Phipps House, located at 1156 East Colfax Avenue, was designed by architect Theodore Boal and was built around 1886. Colfax Avenue has long had an unsavory reputation, but it was one of Denver's elite thoroughfares between 1890 and 1910. Lawrence C. Phipps was a U.S. senator and former vice president of Carnegie Steel. (Courtesy of the Colorado Historical Society.)

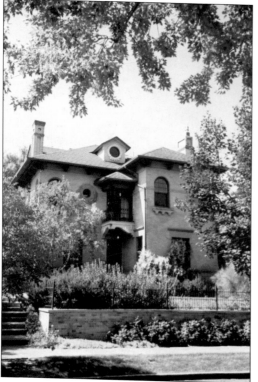

Capitol Hill still offers an array of architectural styles, from Queen Anne and Second Empire to mission style, Italianate, and art moderne. The neighborhood was built up slowly from the 1880s onward, and a few of the best examples from each era survive to this day. Shown at left is a residence in the 900 block of Pearl Street.

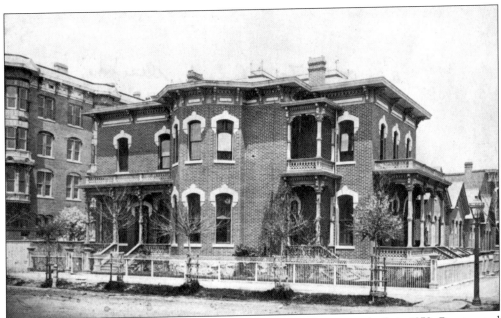

The Frederick Steinhauer House, located at 1701 California Street, was built in 1879. Constructed at 429 California Street and renumbered in 1886, this house typifies those of the professionals who lived and worked in downtown Denver. Until the early 1900s, downtown was filled with apartment houses and private homes. Commerce pushed most of these out, and there are few examples left standing. (Courtesy of the Colorado Historical Society.)

Capitol Hill was a barren plain until it was taken over by Denver's wealthy families who were looking to build a neighborhood unto themselves. But it was never truly exclusive, and the mansions of the city's movers and shakers were soon joined by apartments, hotels, and shops. Dotted among these were dozens of fine, smaller houses and townhouses. (Courtesy of a private collection.)

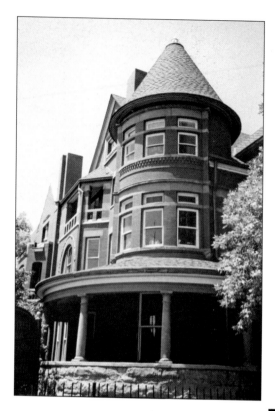

The Dennis Sheedy House, located at 1115 Grant Street, was designed by architects Erasmus T. Carr and William Feth and was built in 1892. One of the few surviving examples of the glory days of Capitol Hill, this Queen Anne–style mansion was built by Dennis Sheedy, a mining executive, cattleman, and operator of the Globe Smelter. Sheedy capped his long career as president of the Denver Dry Goods Company downtown.

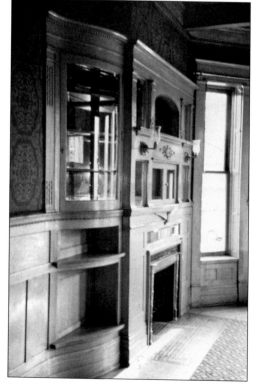

Sheedy remained president of the Denver Dry Goods until his death in 1923. He poured a great deal of money into his dream house. Heavy woodwork, including beamed ceilings and elaborately carved fireplaces, can be found throughout. The house retains many of the original features, such as brass light fixtures and doorknobs, and a variety of stained-glass windows.

After Sheedy's death, his widow, Mary, moved to 777 Logan Street, and the Grant Street house became a center for the arts, with studios for piano teachers, dance teachers, voice coaches, musicians, and painters. This was a period of great change in Capitol Hill, when mansions were sold and subsequently used for everything from rooming houses and apartments to boarding schools.

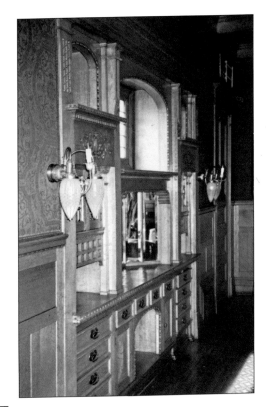

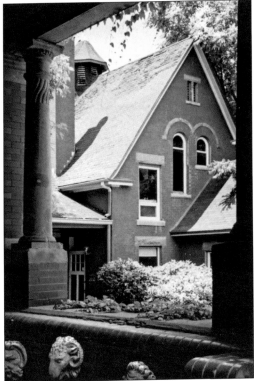

To the north was a large stable (pictured here). The Sheedy house later became the Conservatory of Fine Arts. Once owned by Helen Bonfils, the *Denver Post* newspaper heiress, the house was sold through her estate in the 1970s and was converted to offices. As the Grant Street Mansion, it serves in that capacity today.

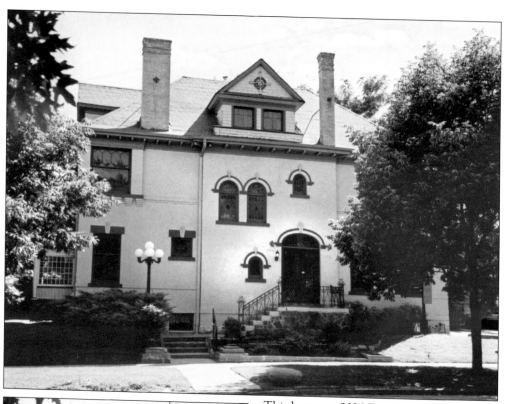

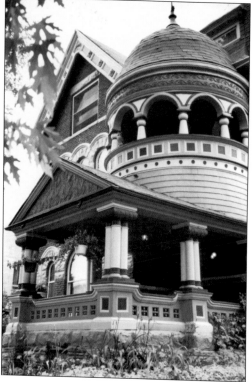

This home, at 2036 East Seventeenth Avenue, was designed by architect George Bettcher and was built in 1903. Shortly after its construction, this house was described in the *Denver Times* as "one of the prettiest homes on Capitol Hill." It was the first to be constructed on the block belonging to the former Denver Orphan's Home. This was the author's childhood home. The rest of the block, part of the Wyman Historic District, was built up between 1904 and 1925.

This Queen Anne–style house is part of an architecturally important section of Vine Street. It is one of five residences, numbered 1415, 1429, 1435, 1441, and 1453, all the work of Denver architect William Lang, that were added to the National Register of Historic Places in 1974. All are extant and are located in the Wyman Historic District. (Courtesy of a private collection.)

BIBLIOGRAPHY

Arps, Louisa. *Denver in Slices*. Denver: Swallow Press, 1959.

Dallas, Sandra. *Cherry Creek Gothic*. Norman, OK: University of Oklahoma Press, 1971.

Denver Building Permits, 1908–1920.

Denver Business Directories, 1924–1930.

Denver City Directories, 1871–2001.

Denver Post. Various editions.

Haber, Francine, Kenneth Fuller, FAIA, and David Wetzel. *Robert Roeschlaub*. Denver: Colorado Historical Society, 1988.

History of Colorado, Illustrated. Edited by Wilbur Fisk Stone. Chicago: S. J. Clarke Publishing, 1918.

Johnson, Forrest H. *Denver's Old Theater Row*. Denver: Gem Publications, 1970.

Jones, William C. and Kenton Forrest. *Denver: A Pictorial History*. Boulder, CO: Pruett Publishing Company, 1973.

Rocky Mountain News. Various editions.

Sargent, Porter. *The Handbook of Private Schools*. Boston: Press of Geo. H. Ellis Company, 1915.

Smiley, Jerome. *The History of Denver*. Denver: Times-Sun Publishing, 1901.

Who's Who In the Rockies. Denver: The Denver Press Club, 1923.

Woven Into the History of Denver; The Colorado Trust Building. Susan M. Thornton, Trish Wakawa, Christopher Craven, John Boak, Kenn Bisio and Gifford Ewing.

www.arcadiapublishing.com

Discover books about the town where you grew up, the cities where your friends and families live, the town where your parents met, or even that retirement spot you've been dreaming about. Our Web site provides history lovers with exclusive deals, advanced notification about new titles, e-mail alerts of author events, and much more.

MADE IN THE USA

Arcadia Publishing, the leading local history publisher in the United States, is committed to making history accessible and meaningful through publishing books that celebrate and preserve the heritage of America's people and places. Consistent with our mission to preserve history on a local level, this book was printed in South Carolina on American-made paper and manufactured entirely in the United States.

This book carries the accredited Forest Stewardship Council (FSC) label and is printed on 100 percent FSC-certified paper. Products carrying the FSC label are independently certified to assure consumers that they come from forests that are managed to meet the social, economic, and ecological needs of present and future generations.

FSC
Mixed Sources
Product group from well-managed forests and other controlled sources

Cert no. SW-COC-001530
www.fsc.org
© 1996 Forest Stewardship Council

Find Your Place in History.